COLOR
THEORY

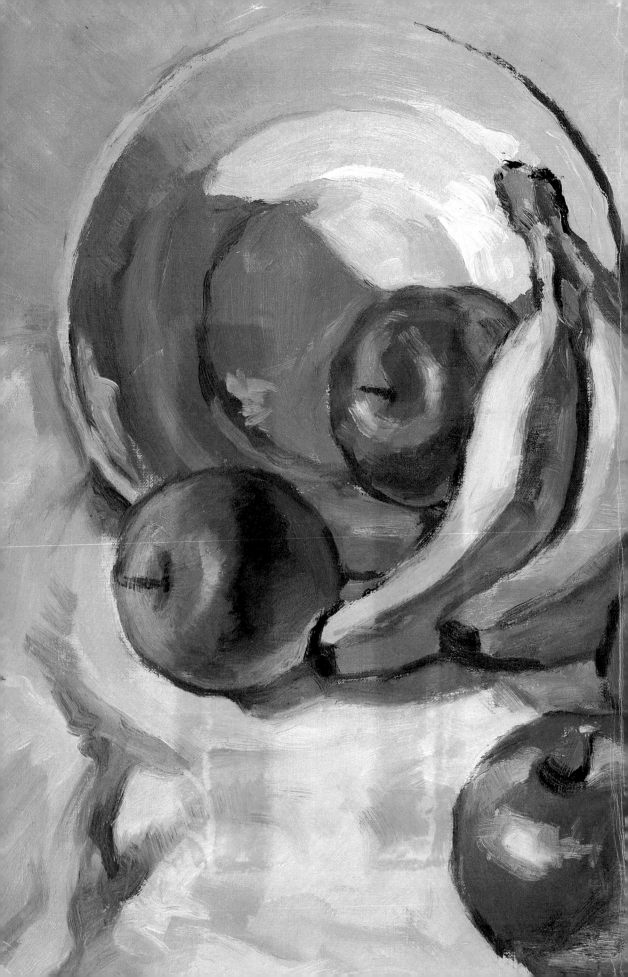

COLOR
THEORY

José M. Parramón

Watson-Guptill Publications/New York

Copyright © 1988 by José M. Parramón Vilasaló
Published in 1988 in Spain by Parramón Ediciones, S.A.,
Barcelona

First published in 1989 in the United States by Watson-Guptill
Publications, a division of Billboard Publications, Inc.,
1515 Broadway, New York, New York 10036

Library of Congress Cataloging-in-Publication Data

Parramón, José María.
 [Teoría y práctia del color. English]
 Color theory / José M. Parramón.
 p. cm. — (Watson-Guptill artist's library)
 Translation of: Teoría y práctica del color.
 ISBN 0-8230-0755-3
 1. Color in art. 2. Painting-Technique. I. Title. II. Series.
 ND1488.P3713 1989 89-5811
 752—dc20 CIP

Distributed in the United Kingdom by Phaidon Press Ltd.,
Musterlin House, Jordan Hill Road, Oxford OX2 8DP

Manufactured in Spain by Sirven Gràfic
Legal Deposit: B. 21.061-89

1 2 3 4 5 6 7 8 9 / 93 92 91 90 89

Contents

Prologue

Dear reader:

I started painting with oils when I was eighteen; I had my first exhibition at twenty-two; and at twenty-four I won the First Youth Salon competition in Spain. (There were seventy-three other painters, all under twenty-five.)

Years later, I went into teaching and gave drawing and painting classes in private academies and schools of fine arts. Finally, I began writing to try to convey my experience and knowledge of drawing and painting.

As an artist and a teacher, one of the themes that really attracted my attention and awoke my interest was the use of color in painting: *color theory and its practical application in painting.*

When I began to study color, I found, to my surprise and astonishment, that most, if not all, books published on color theory still talked about a spectrum of seven colors that still included *indigo.* They failed to take into account that color photography and television had demonstrated, physically and chemically, by means of the *additive* and *subtractive synthesis* of colors, that there existed only *three primary colors* and *three secondary colors,* six in all. It is, therefore, impossible in theory or in practice to have a seventh color.

I also discovered that many writers still think of orange as one of the primary pigment colors. However, it has already been demonstrated, not only by photography and television, but also by photomechanics and graphic arts, that subtractive synthesis does not consist of the mixture of yellow, blue, and orange, but of the mixture of yellow, blue, and *crimson.* Crimson is a light red color scientifically and technically known as *magenta,* a name adopted by photographers and graphic artists when they print in full color, with just three colors and black.

And then I started to write this book, with the idea of divulging new ideas and concepts. I wanted to develop a new interpretation that would allow a painter to explore and put into use color theory, which was generally considered as something abstract.

Forgive my lack of modesty if I say that I think I discovered new ways of learning how to paint, starting from a knowledge of color theory. I began by studying the phenomena of the *colors of light* and the *pigment colors,* and I ended by experimenting with the Young synthesis, applied to the three primary pigment colors. Since I was painting with watercolors, I chose *cadmium yellow medium, Prussian blue,* and *madder* (as you know, you do not use white in watercolors). By experimenting for hours and days, I came to the conclusion that by mixing these three colors together—just these three and no others—it was possible to obtain *every single color* in nature, including black.

From this initial discovery, I reached other practical conclusions about contrasts and complementary colors. It has helped me to determine the factors of color, the color of shadows, and the ranges of harmonizing colors.

Here is the result. I think the following pages will give you an easy, clear, and up-to-date introduction to *color theory.*

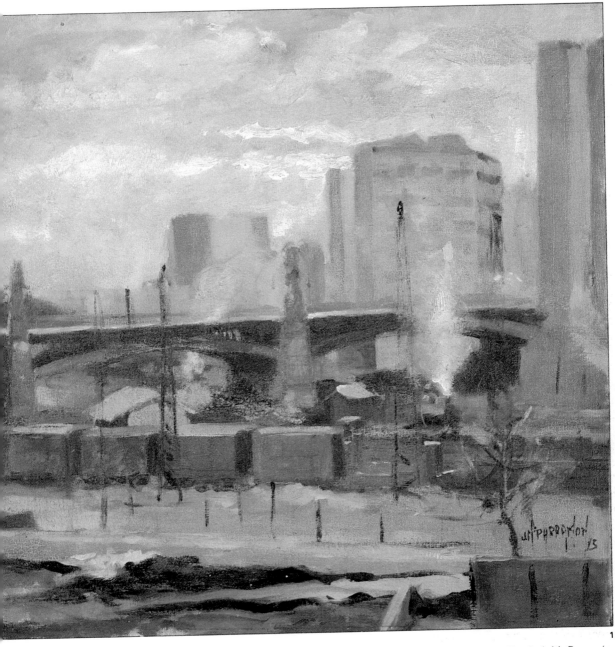

Fig. 1. J. M. Parramón, *The Bridge over Calle Marina,* private collection.

For artists, all color theories can be summed up in this phrase: *"With only three colors, yellow, blue, and magenta (or crimson) mixed together, you can paint all the colors of nature."* This is a fact that you probably know and have, perhaps, tried out for yourself. But why? Why just three colors and why these three in particular? Why is a banana yellow, a tomato red, and the sea blue? The answer to these questions can be found in the first chapter about color theory. When you know the reasoning behind this theory, you will better understand, among other things, the way the *fauves* painted; the range of broken colors used by Vuillard; why Delacroix said that he could paint a nude Venus of unequaled beauty with the color of mud, provided that he was allowed to choose the color of the background . . .

2

-COLOR-
THEORY

A wonderful experiment

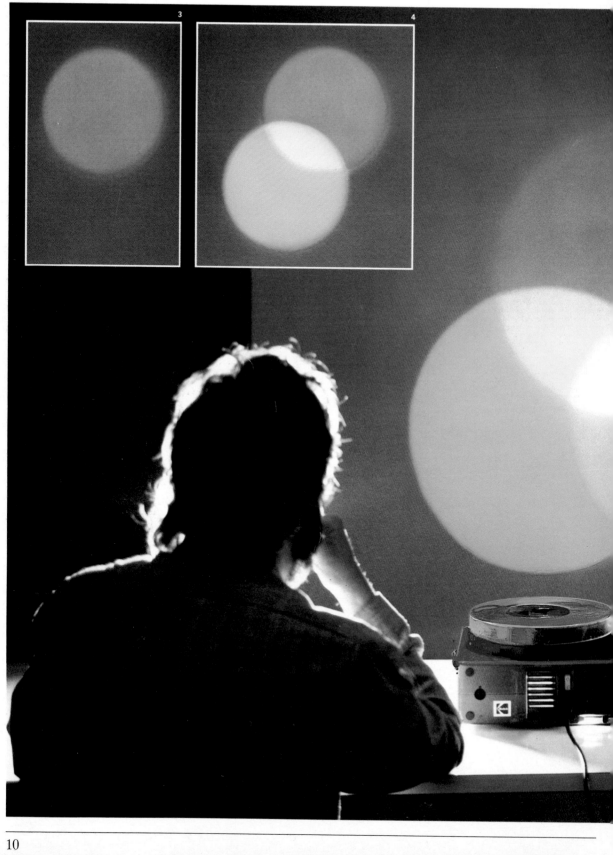

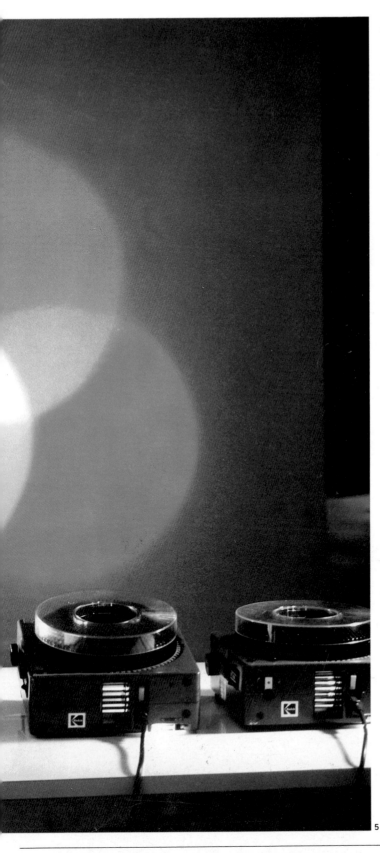

I switched off the light and walked into a dark room where there were three slide projectors. Each projector had a colored filter: one red, one green, another blue. On the wall hung a white sheet that served as a screen.

In the dark, I pressed the button of the first projector; the light came on and a red circle appeared on the screen (figure 3).

Then I switched on the second projector. A circle of green light was projected beside the red (figure 4). I moved the red beam onto the green and a brilliant, luminous yellow shape appeared. (YELLOW! Any amateur painter, however limited his experience, knows that green mixed with red gives you brown, a dark brown, a kind of chocolate color; but . . . yellow?)

I switched on the third projector with the blue filter and moved the blue circle on top of the yellow. The mixture of red, green, and blue created a patch of WHITE LIGHT (figure 5).

At that moment, it felt as if my whole experience as a painter had collapsed. I felt an urge to show someone this extraordinary phenomenon. Extraordinary to me, a painter, who wanted to test with his own eyes the strange theory of Thomas Young, a famous nineteenth-century English physicist, who wrote:

> **Three beams of light, one dark blue, one intense red, and another intense green, when superimposed on one another, give a clear, brilliant white light; in other words, they reconstruct light itself.**

Light and its colors

Imagine that it is a summer afternoon; you are in the country. The earth is damp; it has just rained and by a strange paradox, the sun is still shining as it sinks into the west. In the clear, radiant ultramarine sky appears a fantastic arch of colors—a rainbow.

In the distance, it is still raining. As you may already know, when raindrops receive rays from the sun, they act like millions of glass prisms, dispersing the light into the six colors of the rainbow.

About two hundred years ago, Isaac Newton reproduced the phenomenon of the rainbow in his house. He shut himself up in a completely dark room and let in a thin beam of light, the equivalent of a single sun ray, through a tiny hole. Then he intercepted the ray with a prism—a triangular glass rod—and managed to disperse the white light into the colors of the *spectrum* (figure 6).

Colors of the spectrum

Magenta
Red
Yellow
Green
Cyan blue
Dark blue

Years later, the physicist Young did an experiment that was the opposite of Newton's. While Newton *dispersed* light into the six colors of the spectrum, Young *reconstructed* light. He projected six color beams of light on top of one another, the six colors of the spectrum, and obtained a white light.

To understand this physical phenomenon, when various intense, dark colors create a lighter color when mixed, you have to remember that these colors are the colors of light. They are colors projected by beams of light that imitate the effects of natural light itself. Thus, you can say that when you add one color of light to another, the mixture will

7

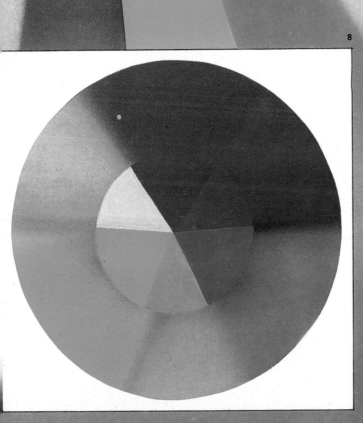

give you a *more luminous, lighter light color*. For instance, by mixing the light color *green* and the light color *red* you will obtain a lighter light color: *yellow*. Young also demonstrated another important color factor. By experimenting with his color lamps, he showed by the process of elimination that the six colors of the spectrum could be reduced to three basic colors of the same spectrum. He found that with just three colors, red, green, and dark blue, he could reconstruct white light (figure 7). And he realized that by mixing those three colors in pairs, he could obtain three others: cyan blue, magenta, and yellow. As a result of this experiment, Young was able to identify the *primary* and *secondary* colors of the spectrum. You can see them in the square below (figure 8).

8

PRIMARY LIGHT COLORS

Red, green, dark blue

SECONDARY LIGHT COLORS

Obtained by mixing the primary colors in pairs.

Green light + Red light
= YELLOW
Blue light + green light
= CYAN BLUE (1)
Red light + blue light
= MAGENTA (2)

(1) *Cyan blue:* This is the technical name used for this secondary light color. The tonality of cyan blue corresponds to a neutral blue of medium intensity.
(2) *Magenta:* This color corresponds to a crimsonish red—called magenta in the graphic arts—of medium tonality.

Absorption and reflection of light

All objects receive the three primary light colors: blue, red, and green. Some objects reflect all the light they receive, while others absorb it. Most objects absorb part of the light and reflect the rest. This law of physics can be summed up as follows:

> **All opaque objects, when they are illuminated, have the property of reflecting all or part of the light they receive.**

No one has unraveled the mystery of why objects have the colors you see in them, and no others. Why is a tomato red? You do know that when a tomato is illuminated, it receives the three primary colors—blue, green, and red—absorbs the blue and green light rays, and reflects the red ones. As a result, you see it as red.

In fact, even this page is receiving the three invisible light colors—blue, green, and red. When the light colors hit the surface of the page, they bounce off; this reflection is the sum of the three light colors, which is the white of the page.

If an illuminated object is black, the opposite will occur. In theory, when the three primary light colors hit a black illuminated object, they will be totally absorbed. This leaves the object without light, in the dark, so to speak, which is why you see it as black.

At the bottom of this page (figure 9), you can see the effects of absorption and reflection on various colored cubes (white, black, red, yellow, and magenta). Notice the colors that reflect and the colors that absorb, giving each cube its particular color.

9

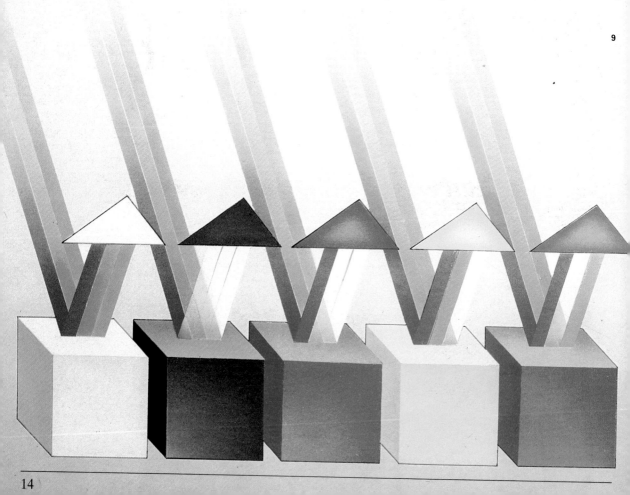

You have seen the colors of light "paint" the objects they come in contact with. When the three primary colors of light are mixed in pairs, they create three other *lighter* colors, which eventually reconstruct light itself—the color *white*—when they are all mixed together.

But it is obvious that you cannot "paint" with light. Or rather, you *cannot create light colors by mixing dark colors*.

Moreover, you cannot avoid the six colors of the spectrum if you want to achieve this imitation of the effects produced by light.

And so, what are you to do? The answer is to simply vary the primacy of certain colors in relation to others. . . still keeping the six colors of the spectrum as the basis. For example:

> **Your primary colors will be the secondary colors of light and vice versa; your secondary colors will be the primary colors of light.**

Now I will explain why this inversion of values takes place.

Additive and subtractive synthesis

The mixtures of pigment colors always mean *subtracting light*, i.e., always going from light colors to dark colors. If you mix the pigment colors cyan blue, magenta, and yellow—three obviously luminous colors—you will obtain black. You obtain the opposite effects when you mix the light colors (figures 10 and 11).

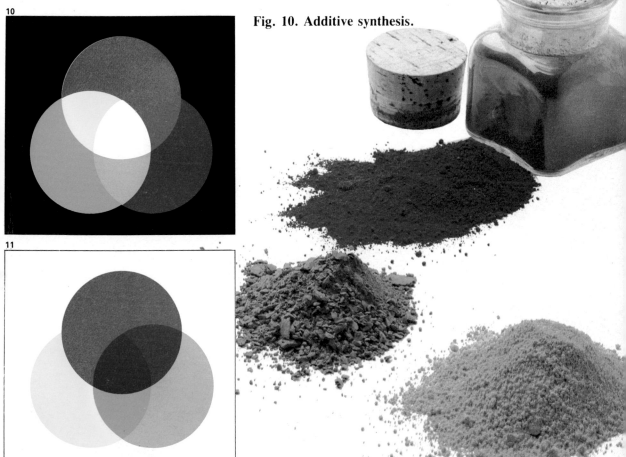

Fig. 10. Additive synthesis.

Fig. 11. Subtractive synthesis.

Light, color, and pigments

Fig. 12. When light "paints" an object, it does so by adding different colored rays of light or by *additive synthesis*.

Fig. 13. When you "paint" with pigment colors, you do so by subtracting light, obtaining the colors by subtraction, or *subtractive synthesis*.

12

13

How light "colors" an object
Additive synthesis: To obtain the secondary light color yellow, the light color red is added to the light color green; when they are mixed, a lighter light color, *yellow*, is produced. Thus, yellow is obtained by the *additive synthesis* of the light colors *red* and *green*.

Knowing about the origin and the theory of colors will help you understand how the polychrome of shades,

How pigments "color" an object
Subtractive synthesis: To obtain the secondary pigment color green, you mix cyan blue and yellow. In colors of light, blue absorbs red and yellow absorbs blue. The only color they both reflect is *green*, which is obtained by the *subtractive synthesis* of *blue* and *red*.

tones, and colors, in the model below, are classified into primary and secondary colors (figure 14).

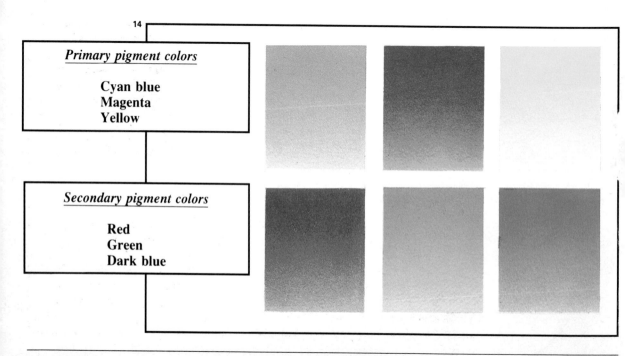

14

Primary pigment colors

Cyan blue
Magenta
Yellow

Secondary pigment colors

Red
Green
Dark blue

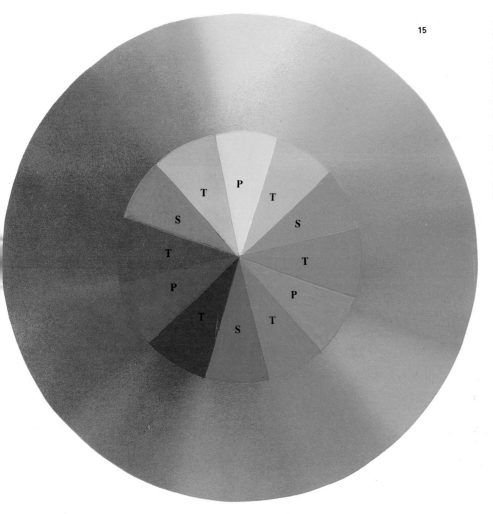

15

Fig. 15. This color wheel shows you the classification of pigment colors, starting from the three primary colors (indicated by the letter P). When mixed in pairs, the primary colors produce the three secondary colors (indicated by the letter S). When the secondary colors are mixed with the primary colors, you get tertiary colors (indicated with the letter T).

16

Mixing *magenta* with *yellow* creates a *red*	Mixing *yellow* with *cyan blue* creates a *green*	Mixing *cyan blue* with *magenta* creates a *dark blue*

By mixing a primary color with the closest secondary color, you can create a **tertiary pigment color:**

Emerald green
Ultramarine blue
Light green
Violet
Crimson
Orange

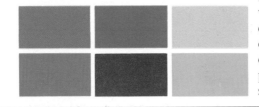

Finally, by mixing the tertiaries with the secondaries, you can create another darker range called the "quaternaries." You can continue this process and produce an infinite number of shades.

Complementary colors

By understanding the theory behind color and light, you can obtain any color on your palette. Next, you will need to know how pigment colors complement one another.

COMPLEMENTARY PIGMENT COLORS
Intense blue complements *yellow*
Red complements *cyan blue*
Green complements *magenta* **(and vice versa)**

Now, you might be saying, what use is this information about complementary colors while I'm painting?
Well. . . look at it this way: if you observe the previous table of pigment colors carefully, you will notice that the complementary colors are always opposite one another in all possible combinations (dark blue complements yellow—or vice versa, don't forget—red complements cyan blue, and so on). To put it another way, because they are complementary, they have the least in common. And to a painter, this means the chance to create surprising contrasts, to paint extraordinarily luminous shadows or intense backgrounds.
It also means the possibility of painting with a range of "broken" colors, obtained with a mixture of unequal proportions of complementary colors and white. But this is a subject that I will leave for later—when I discuss toning, tendencies and ranges, and the art of harmonizing colors.

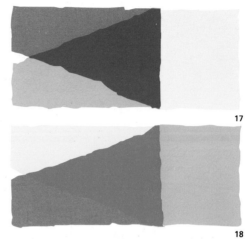

17

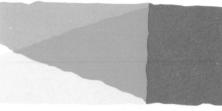

18

19

Figs. 17, 18, and 19. The theory of complementary colors can be summed up in these diagrams: when two primary colors (magenta and cyan blue) are mixed, you obtain a secondary color (intense blue), whose complement is the primary color that was not included in the previous mixture (yellow). Reading each diagram you can see that intense blue is the complement of yellow; red is the complement of cyan blue; and green is the complement of magenta, and vice versa.

20

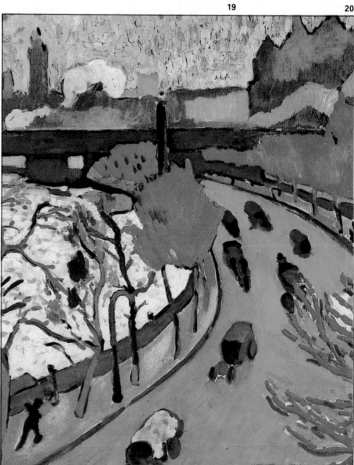

Fig. 20. The use of complementary colors allows you to obtain the most intense color contrasts. At the beginning of this century, the post-impressionists and the *fauvists* emphasized color contrasts in their paintings. An example of this style is this reproduction of André Derain's painting *Westminster Bridge* (private collection, Paris).

Complementary colors
Let me review once again that by projecting three beams of light, one red, one green, and another intense blue, you can reconstruct light itself and obtain a white light. When you take away the blue beam, the complementary color of blue—yellow—appears on the screen.

FOR PAINTERS . . .

YELLOW is the complement of BLUE
MAGENTA is the complement of GREEN
CYAN BLUE is the complement of RED
(and vice versa)

COMPLEMENTARY
PIGMENT COLORS

They are the same as the primary light colors—blue, green, and red. Since these colors take away light, when mixed they create black.

21

Color theory: summary

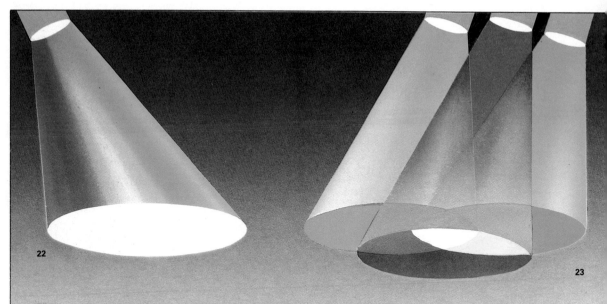

22

23

- White light is the total of all the colors of the spectrum, basically composed of the primary *light* colors: blue, green, and red.
- By mixing the primary *light* colors in pairs, you obtain three colors of a lighter tonality. They are the secondary light colors: cyan blue, magenta, and yellow.

- The mixture of the primary *light* colors (blue, green, and red) creates a white light.
- Most objects either reflect all or part of the light they receive.
- Light "colors" objects by means of additive synthesis.

24

25

- Painting with pigment colors is the opposite process to the one applied to light. Mixing pigment colors always involves taking away light, subtractive synthesis. For instance, by mixing the three primary *pigment* colors, you create black.

- However, the colors of the spectrum can be found both in the colors of light and in pigment colors.

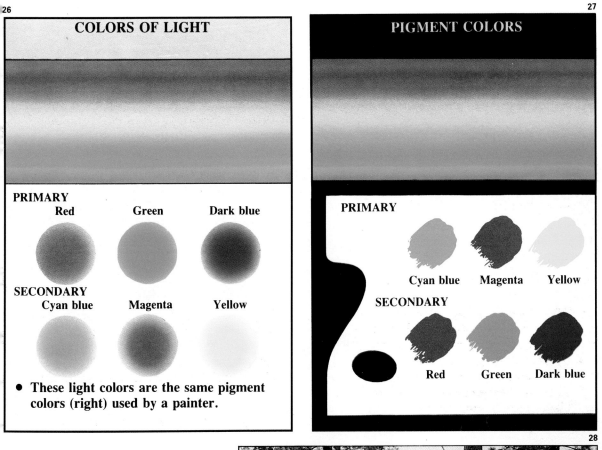

26

COLORS OF LIGHT

PRIMARY

Red Green Dark blue

SECONDARY

Cyan blue Magenta Yellow

- These light colors are the same pigment colors (right) used by a painter.

27

PIGMENT COLORS

PRIMARY

Cyan blue Magenta Yellow

SECONDARY

Red Green Dark blue

28

- This coincidence allows an artist to imitate the effects of light in illuminated objects and to reproduce all the ranges of color that nature has to offer.

The major pigment manufacturers usually offer a choice of 100 to 130 different colors. Some color charts show over twenty yellows: *cadmium yellow, chrome yellow, Naples yellow, Indian yellow.* . . . But curiously enough, if you wanted to paint a bunch of bananas and chose the most compatible yellow on the chart, you would still have to add other colors to create the true banana colors.

Like all objects, bananas, apart from their own specific color, have a series of color variables, such as the effects of light and shade, the reflected light, the intensity of light, and the atmosphere. I will be discussing these factors in this chapter and will try to answer the question the painter usually asks himself when looking at a subject: *"What color is it?"*

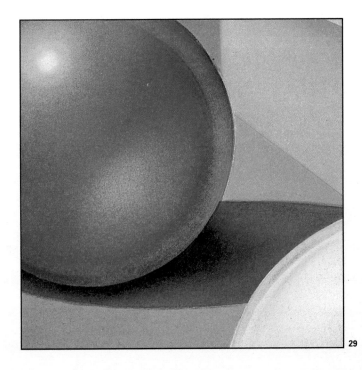

29

COLOR
-OF THE-
SUBJECT

What color is it?

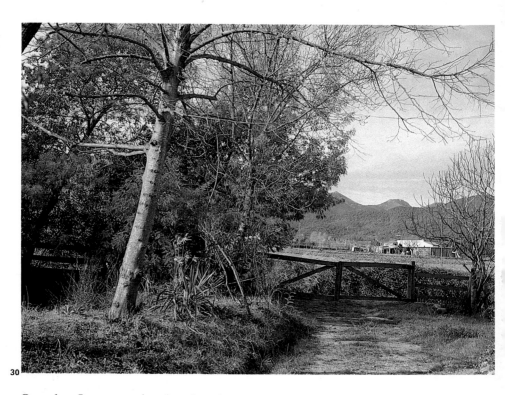

30

One day I was passing by the above site and stopped as if by instinct. I was trying to find a good subject for a painting.

I sat down and stared for a while. Then I looked for the sun, noted the green of the trees, and tried to determine the color of the mountains. I started to wonder, "What color is it?"

* * *

After sketching the masses and contours with a carbon pencil, I then placed the oil colors on my palette.

I looked at the sky and wondered again: "What color is it?" Blue, of course; sky of blue, but. . . that "blue" was very vague. And then I began mixing each shade of blue with white and no other color. After a while, I realized that I wasn't going to capture the *sky blue* that I saw in front of me in this manner. Well then, what color is it? The light cobalt seemed right, toned down with white, and . . . a pinch of crimson . . . a bit more lemon yellow. Then I thought the sky looked a little gray.

Next, I focused on the green of the trees. I had three tubes of green: permanent light green, emerald green, and sap green.

Ah, but . . . none of those greens, even when toned down with white, was exactly the same as the complex color range of the trees!

I had to opt for one of the three greens . . . perhaps mixing the two greens and adding a touch of yellow, blue, and ochre. . . .

And then the mountains in the background . . . a blue-gray. They really are gray! Finally, the color of the earth and the shadows of the fence. Here I thought of ochre and natural sienna—true earth colors! But none of them was the color of the earth of this landscape. So once again I started mixing and testing, lightening with yellow and white, darkening with dark umber and brown, and . . . gray; I was left with gray. I had spent two hours struggling, sinking willy-nilly into a swamp of grays.

* * *

I had had enough; I was tired. When I picked up my palette for cleaning, I looked down and saw only one color scheme—gray!

* * *

This is a scenario many people can relate to. It's not difficult to fall into the hidden trap of the grays, almost without realizing it. In order to avoid this, you must find the answer to the question, "What color is it?"

Local color, tonal color, reflected color

By studying the following color factors, you can assimilate the variables and determine the color of a subject.

> To a greater or lesser extent, all illuminated subjects have three color factors that you should keep in mind.
> a) The *local color:* its own specific color.
> b) The *tonal color:* the color variations that result from the effects of light and shadow.
> c) The *color of the environment:* the color reflected by other surrounding objects or elements.
> These three factors are, in turn, conditioned by:
> d) The color of the *light.*
> e) The *intensity* of the light.
> f) The intervening *atmosphere.*

Local color (figure 32)
This is the true color of an object.
Some colors are obvious, for example, a blue flower, a red sphere, or a yellow dress. But, when objects with volume are illuminated, different color tones appear because of the effects of light and shadow. Moreover, an object can pick up reflections of other colors from surrounding objects.

Tonal color (figure 32)
This is the local color changed by the effects of light and shadow. In most cases, the tonal color is almost always influenced by the reflected colors of surrounding objects. Tonal color is, therefore, more or less a variation of the local, or intrinsic color, usually influenced by the reflection of other colors.

Reflected color (figure 32)
Any object you look at is influenced by the color of the environment. These colors are reflections of surrounding objects. For instance, the wall of a

Other color conditioners

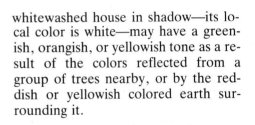

whitewashed house in shadow—its local color is white—may have a greenish, orangish, or yellowish tone as a result of the colors reflected from a group of trees nearby, or by the reddish or yellowish colored earth surrounding it.

The color of the light (figure 34)
All outdoor environments are subject to the changes of light that occur during the day. At dawn, the light may be a transparent bluish white. At midday, in the full sunlight, it may be white, with a tendency toward yellow. On a cloudy day, the light will seem grayish. At dusk, the light may have an orange color. In northern regions, the light is "cooler," with a tendency toward blue. In southern regions, the light is "warmer," yellower. Artificial light is usually yellow; fluorescent light can be pink or blue.

The intensity of the light (figure 34)
Natural light is white. In full daylight, objects appear to be saturated with color (blues, reds, yellows, and so on—particularly the reds and the yellows) as well as reflect their local color, fully and intensely.
When natural light fades, the intensity of the colors fades, too. Although it is true that the total absence of light leads to black, it is also true that:

> **A decrease in the intensity of natural light leads to a bluish light, which tends to impregnate all colors with blue.**

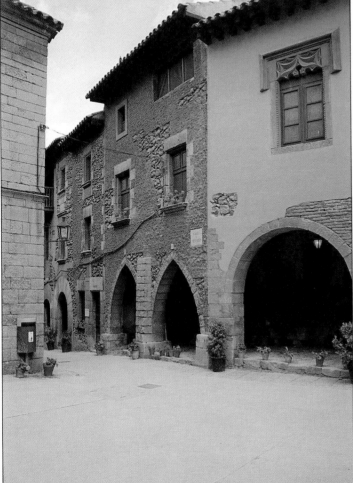

Figs. 33 and 35. Sunlight intensifies and saturates colors; it brings out the local color of an object. On a cloudy day, or when an object is in the shade, there is a bluish gray cast; in such a case, the colors are usually broken colors, which are always mixed with blue (right).

Color and contrast conditioned by the atmosphere

36

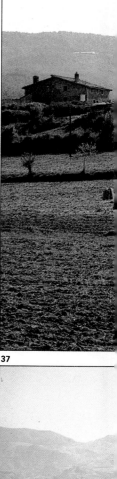

37

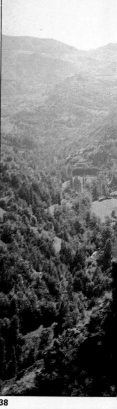

38

Have you ever seen mountains on a horizon? They appear to have a bluish color to them.

How about the classic panoramic view of a large city, seen from above? An overview, where nearby houses and buildings present a marked contrast to the distant buildings that seem to blend in a mass of violet, gray, and blue tones.

Of course, the local color, the intrinsic color, of mountains on a horizon is not blue; neither is the distant building that you may see in a panoramic view of a city.

In fact, the mountains may be green or a light or dark earth color. The buildings may be white, red, or brown. It is through the effect of the intervening atmosphere, the distance and space between you and the object, that these objects look blue to you. Depending on the intensity and color of the light, you may see a violet, an intense purple-blue, or a grayish blue.

Below is a summary of the three effects of atmosphere.

1. **Accentuated contrasts between the foreground and the distant grounds.**
2. **In a receding subject, there is a tendency for colors to fade and a tendency toward gray (to blue, when you are painting).**
3. **There is clarity of the foreground in comparison with the more distant objects in the background.**

This concludes the basic study of the main factors that determine the color of a subject. Hopefully, I have explained some of the mysteries posed by the question, "What color is it?"

Now, I will take another step toward providing you with techniques for composing, mixing, and finding the colors of a subject.

39

Figs. 37 to 40. You can see in these photographs the effects of atmosphere in an open countryside, in the woods, in the high mountains, and in a city by the sea. Except for the last photograph, notice how the intervening atmosphere enriches the colors of the foreground. As the ground recedes, the color fades and there is a tendency toward blue. A strong contrast between the foreground and background is created by the atmosphere.

40

In the previous chapters, you have learned about the foundations of color theory. They are essential for an artist to know in order to paint a picture. In the next section, I will apply the basic principles of these theories, using only three colors —blue, yellow, and crimson, with a little help from white. With these three colors you can paint all the colors of nature, including black. The painting demonstrations could be done on any subject, from a landscape to a bunch of flowers. However, you will not be experimenting with subjects, but with ranges of colors applied to different subjects: a range of khakis and greens, flesh colors, and grays. It would be ideal for you to test and experience these lessons on painting with only three colors as you read along. I hope you do so.

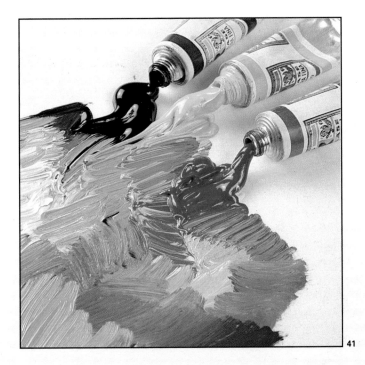

41

ALL THE COLORS
—OF NATURE WITH—
ONLY THREE COLORS

Khakis and greens

> **With the three primary colors —*cyan blue, magenta (crimson),* and *yellow*— it is possible to obtain all the colors in nature, including black.**

Theoretically this is true, but in practice, you have to add white to these three colors. White can be the color of the paper itself (when you're painting with watercolors, for example), or can be used as a color when painting with oils or other opaque materials. In any case, to obtain a pink, you have to tone down the crimson shade with white. In oil painting, to obtain a light green, you have to mix the yellow and the blue and add white from the tube. Or in watercolors, you have to dilute the green with more water to obtain a greater transparency from the white of the paper.

From what you have learned so far, the following factor is something you should bear in mind: whatever the color of the subject, its composition will always include one part blue, another part of a crimson shade, and another part yellow.

Let me show you some examples:
I will begin the exercise by composing the color khaki—the well-known color of an army uniform. I will mix the three primary colors with white in the correct proportions.

I will paint the mixtures with oils on white canvas. I have tried to find three colors whose range is as close as possible to the primary colors. You can see the colors I have chosen in the illustration at the bottom of the page.

Now let me make khaki.

To obtain a neutral green, I mix yellow with blue (add more yellow). Now, by adding a little madder (a crimson shade), I create a khaki color (A).

But, of course, not all army uniforms are the same khaki color. When I add a little yellow and a touch of white to this khaki, I get a rather grayish khaki, less striking than the previous one (B). If I add another small portion of yellow and white, I will get a faded khaki (C). If I add blue, madder, and white, I will get a khaki to paint the shadows of the uniform (D).

42

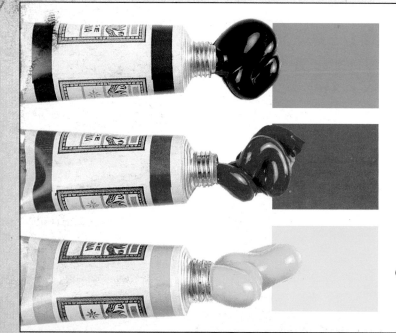

For the cyan blue
PRUSSIAN BLUE

For the magenta
MADDER

For the yellow
CADMIUM YELLOW LIGHT

A

B

C

D

Flesh colors

Now let me show you how to paint a *flesh color,* another complex color that is neither pink nor light yellow nor orange. By using the same primary colors that you used for khaki, with the help of white, you can create a flesh color: a little yellow, a larger amount of white, and a tiny portion of a crimson shade (note, there is no need to add blue) (A).

This is a very luminous flesh color. It can be used to paint highly lit areas, the most brilliant areas of the model.

You can "darken" the color by adding a touch of blue, and by doing so, you obtain a true-to-life, local flesh color (B).

A variant of this local color can be obtained by adding a tiny bit of crimson (C); if you add a little more crimson and more yellow to this mixture, you will get a bronze flesh color (D); and if . . .

Maybe I should stop here. As you can see, the mixing of *flesh colors*—in fact, you can say of *all colors*—is very relative. You cannot speak of a specific *flesh color*. There are many flesh colors and many factors such as the local color, the tonal color, the reflected color or colors, and other factors that I will discuss later—whether it is a light, dark, rosy, olive, green, or even blue tone of flesh color.

For an example, look at the sketch of the head that I painted in oil, in figure 44. It is difficult to determine exactly how many colors and shades make up the color and shape of the different parts of the face. From dark sienna to light blue, the color range includes pink, ochre, cream, light green, dark green, black, and so on. This extraordinary variety of colors was obtained with the mixture of the three primary colors.

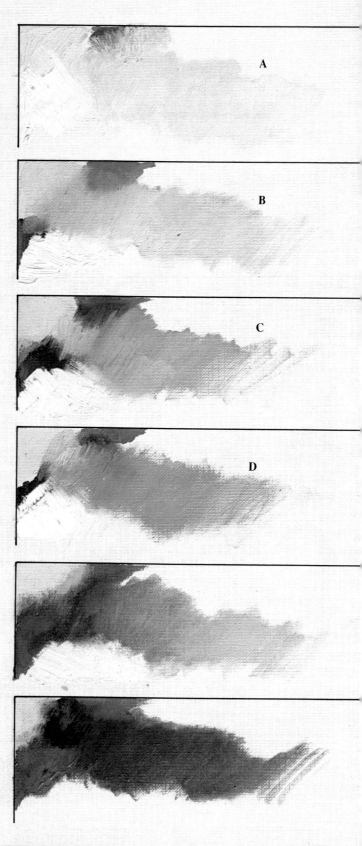

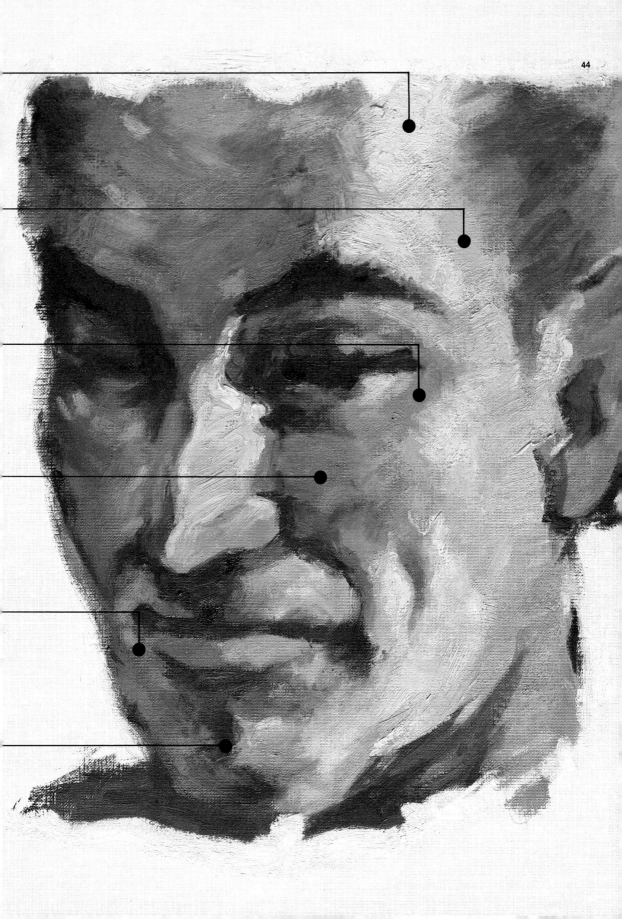

Grays

Can the three primary colors also give you gray? Yes, of course, very easily. All you have to do is mix them in the correct proportions (approximately 50 percent blue, 30 percent red, and 20 percent yellow). This mixture will give you black, and then you need to add white gradually until you produce the gray you are looking for. Try mixing a gray to match figure 46 (A). By varying the proportions of the primary colors, it is also possible to obtain different ranges of grays: "cool" grays, with a bluish (B) or greenish (C) tint, or "warm" grays with a yellowish (D) or reddish (E) tint.

As I mentioned before, it is very easy to make the color gray; in fact, too easy, unfortunately. This may be why so many amateur painters tend to produce paintings that have poor coloring —monotonous and gray.

Well, you may say, "I paint with more than three colors; my mixtures cannot be reduced to blue, red, and yellow. Look at my palette: I am working with three yellows, two siennas, two reds, a crimson, three greens, three blues . . ."

But in the end, all those colors are derived from the three primary colors. In fact, it doesn't matter whether you mix the three primary colors in the proportions I have mentioned or whether you obtain the mixture with the secondary or tertiary colors. You will obtain the same gray by mixing cyan blue, crimson, and yellow as you would by mixing the secondary colors, red, green, and intense blue, or by mixing the tertiary colors, light green, emerald green, ultramarine blue, and violet.

Now you might be saying, "What is the purpose of all the different pigment shades of blue, sienna, green, and yellow if you can paint everything with the three primary colors? Since the 'gray trap' also exists when you work with a number of colors on your palette, why can't I just use the primary colors?"

This is a crucial question, which I will answer in the next chapter. I will show you why and how colors are used in painting. There is also a discussion about factors that may have prevented you from painting pictures with brilliant, vivid, and true colors, and of topics such as the use and abuse of white, the lack of contrast, and the use of complementary colors.

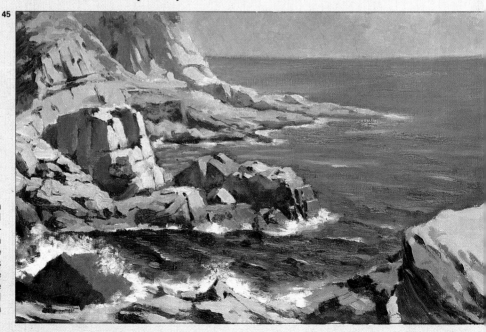

45

Fig. 45. This detail of a seascape, which I painted, is a good example of the contrast in atmosphere and of the wide range of tones and shades that can be derived from the three primary colors (which I will discuss further in the following chapters).

A

B

C

D

E

The French art critic Charles Blanc, a contemporary of Delacroix, wrote this anecdote in his *Grammaire des Arts du Dessin:*

"One day, Delacroix was painting a yellow garment, but try as he might he could not obtain the contrast that he remembered from the yellows of Rubens and Veronese. Suddenly he decided to go to the Louvre Museum to see what his predecessors had done. Forgetting his overcoat, without washing his hands, he ran out into the street in his shirt sleeves. In the full sunlight . . . he glimpsed, rather glanced, at the radiant yellow stain of a hansom cab opposite his house. He jumped in and shouted to the coachman, 'To the Louvre, as fast as you can.' But no sooner had he spoken than the fleeting vision of the yellow of the cab came back to his mind. 'That's it,' he said to himself. He got out . . . glimpsed . . . glanced . . . Yes, *is was a MORE luminous yellow because of the contrast with the violet blue color of the shadows.* 'Chevreul's laws of complementaries!' thought Delacroix, and then he left the cab and ran back to his studio, without a word, while the coachman thought, 'That fellow must be mad.' "

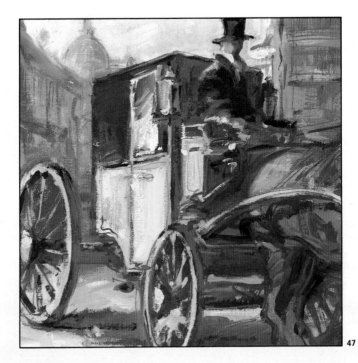

47

COLOR
— AND —
CONTRAST

Contrast through tone and color

Pigment colors are actually a poor comparison to the colors and lights found in nature. The following test will show you an example of the difference between natural and pigment coloring. Imagine a white wall that has a small hole, which looks into a black space without light. If you were to paint, with black paint, a shape equal to that of the hole next to it, you would see that the black paint would transform into a dark gray and not the real black of darkness (figure 48).

In order to imitate the real contrasts, which exist between the colors in nature, you have to use a series of rules based on the factors of contrast between *tones* and *colors*.

A contrast produced through *tone* does not involve color; instead, it deals with the lightness or darkness of a color. For instance, a black beside a white, a dark gray and a light gray, or a combination of black, gray, and white are examples of tonal contrasts. A dark blue and a light blue is another tonal contrast.

However, if you paint a dark red beside a dark blue, you obtain the contrast of one color with another. A color contrast is based on the differences that exist between two colors. Finally, if the blue is dark and the red is light, you achieve a double contrast given by *color* and *tone* at the same time (figure 49).

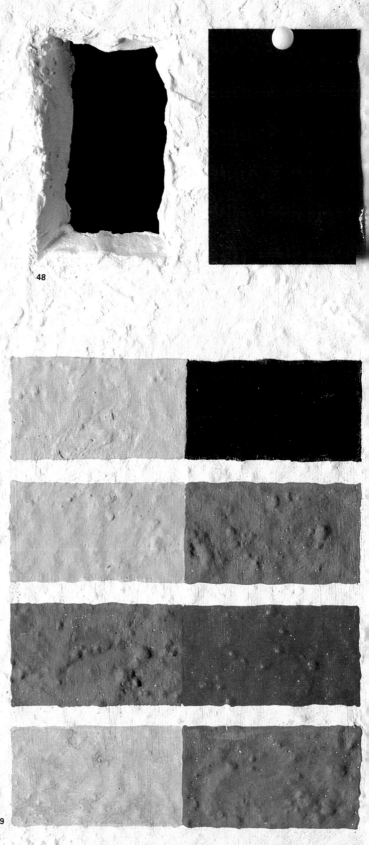

48

49

The law of simultaneous contrast

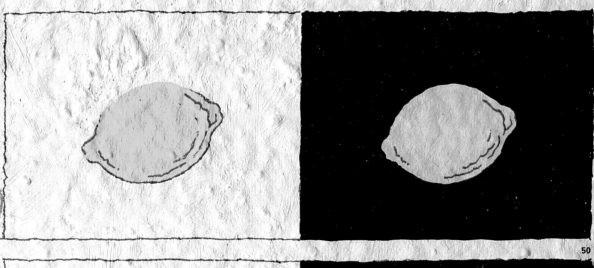

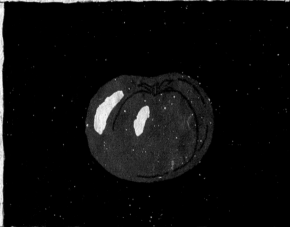

50

51

When you have an area of light color and another area of dark color, and you paint the same color on top of both —a yellow lemon and a red tomato in this case—you will get the optical illusion that the yellow of the lemon, or the red of the tomato, placed on the white surface is darker than the same color placed on the black background (figures 50 and 51). This is known as *simultaneous contrast*.

The following conclusions can be added to your study of color:

> 1. **A color appears darker when the color around it is lighter.**
> 2. **A color appears lighter when the color around it is darker.**

Enhancement of colors

Now I will broaden the scope of this lesson with a new experiment. You will be painting the gradations of a color, any color, a red, for example, in a series of strips. From this experiment, you will see how the color of one strip enhances the color of the neighboring or juxtaposing strips. You can see an example of this exercise in figure 52. There you see a gradation composed of six *tonal* strips of the same color. If you analyze any one of the strips alone, isolated from the neighboring strips, you will find that there is no *tonal* variation within that strip. The color of each strip is regular, flat, and uniform. But when you look at the same strip beside the neighboring ones, you see a toning take place, *producing an obvious lightness on one side and a darkness on the other side.*

To sum it up, the gradation diagram shows that:

> **The juxtaposition of two colors in different tones enhances both colors, making the light one lighter and the dark one darker.**

This is important for you to remember. It shows that through tonal contrast, *color is enhanced* and a color contrast can be obtained. It also tells you that a color seen by itself has a different shade than when it is seen next to another color.

52

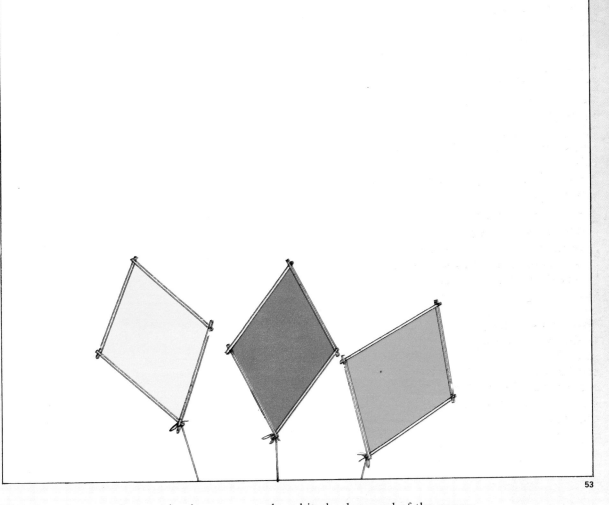

The phenomenon of successive images is truly a curious effect discovered by the physicist Chevreul. Now you can test it for yourself with the three rhomboids, or kites, printed on this page, in the three primary pigment colors: *yellow, magenta,* and *cyan blue*. First you must stare at the three kites for half a minute in good light. Once the thirty seconds have passed, look higher up on the white background of the paper; you will see the same kites in their complementary colors. (Actually, what you will see are rhombs, or luminous shapes, with characteristics like those of fluorescent lights.)

Maximum color contrasts

To obtain a maximum contrast through tone, you just have to paint black next to white. But what about finding the maximum contrast through *color?* Which colors should you use? Blue and green? Red and yellow? Violet and red?

> **Maximum color contrasts can be produced from the juxtaposition of complementary colors (figure 55).**

The number of complementary colors is almost infinite. It is not restricted, as one might believe, to an exclusive combination of the primary and secondary colors.
From what you have learned so far,

here are some points to remember:
When placed side by side, two colors can be enhanced in their tone and in their color. On the other hand, the phenomenon of successive images also takes into account the maximum color contrast provided by the complementary colors. It becomes evident that a color creates the appearance of its complementary color in its neighboring color or shade.
It was the color physicist, Chevreul, who discovered and standardized this important phenomenon.

Fig. 54. Henri Matisse (1869-1954), *Portrait of Madame Matisse,* also known as *Portrait,* Royal Fine Arts Museum, Copenhagen. First the post-impressionists and then the fauvists painted with maximum color contrasts by juxtaposing complementary colors—similar to what you see in this painting by Matisse.

54

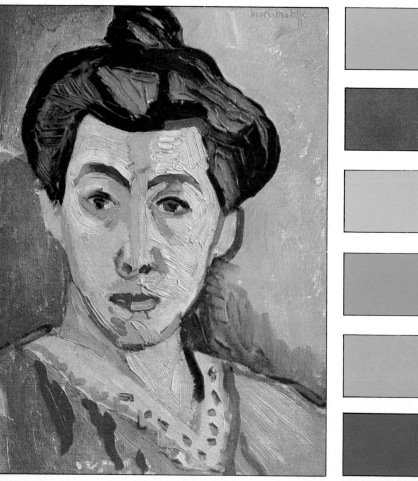

55

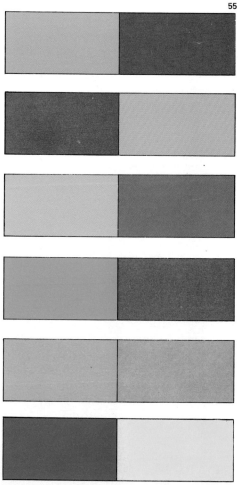

Induction of complementary colors

A color will cast its complementary color onto a neighboring color or shade.

Test for yourself this unique phenomenon developed by Chevreul with the triangles on this page.
First, stare for half a minute at the green triangle on the yellow background, and then at the green triangle on the dark blue background (figures 56 and 57). You will notice immediate-ly that although the two greens are identical, the one situated on the yellow rectangle has a slight bluish tone, while the one on the blue rectangle has a slight yellowish tone. The first rectangle (figure 56) is receiving an induction of blue, the complementary of yellow. The induction also gives the triangle a bluer green than the second rectangle. The effects are reversed for figure 57.

Figs. 56 and 57. If you look for half a minute at the triangle on the blue background and then at the triangle on the yellow background, you will see the induction of complementary colors.

There is a yellowish tone on the triangle with the blue background, and a bluish tone on the triangle with the yellow background.

56 **57**

From theory to practice

Delacroix once said, "Give me mud and I will paint the skin of a Venus . . . with the condition that I can paint around her the colors I want." Delacroix knew that with certain colors in the background, it is possible to create a delicate flesh color.

On one occasion, someone begged Rubens to accept as a pupil a young man who was very keen and very willing.

"He will settle for anything. To begin with, he could help you paint the backgrounds. . . ."

"Ah, he can paint backgrounds?" Rubens asked. "Bring him along right away; I have been painting for years, and I have never been able to paint a background properly."

Rubens, like all great artists, had a premonition of the modern color theories. That is why he thought that the task of painting a background, while appearing simple, was in fact very complex.

You are now going to study these theories from a practical point of view. To do this, you will be using as an example, an oil painting by the artist Francesc Serra. *Figure 58*. Here is an image of a young model, dressed in a white blouse and a brown skirt against a white background. This is an example of simultaneous contrast. Against a white background, the tone of the face is dark, grayish, and leaning toward green. The blouse looks more gray than white; the book is also part of this brownish, greenish tonality.

Figure 59. This is the result of the induction of the background colors. I have painted the same figure on a reddish background; I have also modified the color of the skirt, giving it a more crimson shade. The results are bad. The red background, leaning toward crimson, is the worst color for the olive green color of the face and the blouse. Since the crimson color casts its complementary color, green, onto the neighboring shade, it only *adds more green to the color of the figure.*

Now, I will show you an example with a yellowish background, with a range of golden colors, including ochres, siennas, yellows . . .

Figure 60. No good either. First of all, the background becomes too important. In the second place, when the colors of the figure receive the induction of the yellowish background, they become more gray. The background colors cast their complementary color, blue (the complementary of yellow), making the color of the face and the blouse paler and more faded.

58

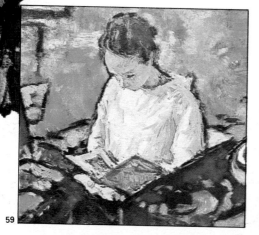

59

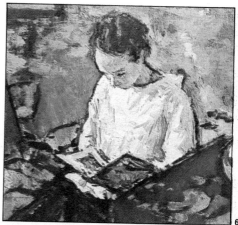

60

Figure 61. Here is Francesc Serra's magnificent painting. It shows you the best background color match. The one which, through the induction of complementary colors, harmonizes and matches the color of the head, the blouse, and the skirt. The colors are not only pleasing to the eye, but they are also original and artistic.

Francesc Serra's picture is undoubtedly brilliant. It shows an extraordinary knowledge of color and the theories you are learning in this book, which, in short, may be defined as follows:

Another important lesson can be learned by studying this painting by Serra. It shows you that in painting, as in drawing, the artist needs to work on the whole painting at once, looking at the entire picture, staining and painting the entire surface, and gradually transforming or matching the colors. For example, you must never paint and *finish* a figure without staining in the background with a color that will be compatible with the figure.

Remember, Chevreul himself wrote this definitive phrase on the subject:

> **Bearing in mind the rule of the induction of complementary colors, you can modify a color by changing the color of the background that surrounds it to its complementary color.**

> **Putting a brushstroke of color on a canvas is not just staining the canvas with the color on the brush. It is also coloring the space around it with its complementary color.**

61

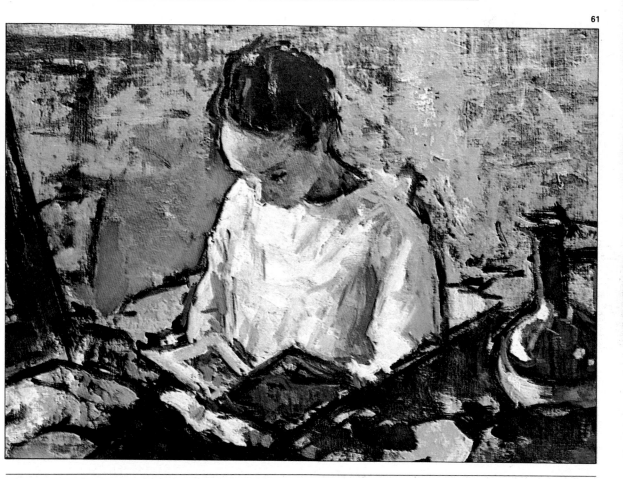

Another important factor to
remember is that it is not
possible to obtain a light color
simply by mixing white into a
color, and a dark color is not
just the result of mixing with
black. When Titian told his
pupils, "Dirty your colors," he
was not talking about darkening
colors with black. He was
talking about painting with dull,
broken colors, with shades
obtained from the mixture of
complementary colors in
unequal proportions . . . and
black and white, but always
mixed with other colors. Never
try to make a color lighter or
darker with just white or black.

62

THE USE
—————AND ABUSE—————
OF WHITE AND BLACK

The color gray is 50% white

To paint the light blue of a cloudless sky or the dark red of a flower, it seems natural, in theory, that you would have the help of white and black. But beware! By using white or black for a light blue, a dark red, and so on, you can fall into the "gray trap, " especially when you are painting with opaque colors, such as oil, tempera, pastel, and so on. Remember that white is a color and will be treated as such in the mixture. Emilio Sala, the art teacher, was right when he wrote:

> **The greatest difficulty with oil painting is to make the white vanish.**

The fact is that white creates gray; white is a basic component—no less than 50%, together with black—of the color gray.

> **Adding white to a particular color means, both in theory and in practice, turning the color to gray.**

Have you ever heard about the experiment with coffee and milk? If you take two glasses of coffee, with the same amount in each, and add water to one glass and milk to the other, you will see that the water makes the color of the coffee lighter, leaning toward red, orange, gold. . . . It reacts in a similar way to the mixture of water with a transparent color such as a watercolor. While in the other glass, the milk transforms the color of the coffee into a dirty sienna, a dirty ochre, a gray cream. . . . It reacts similarly to the mixture of a white color—an opaque color—with another equally opaque color (figure 63).

This experiment will help you to understand an important rule:

> **Adding white to a mixture is not the only way to obtain a lighter color.**

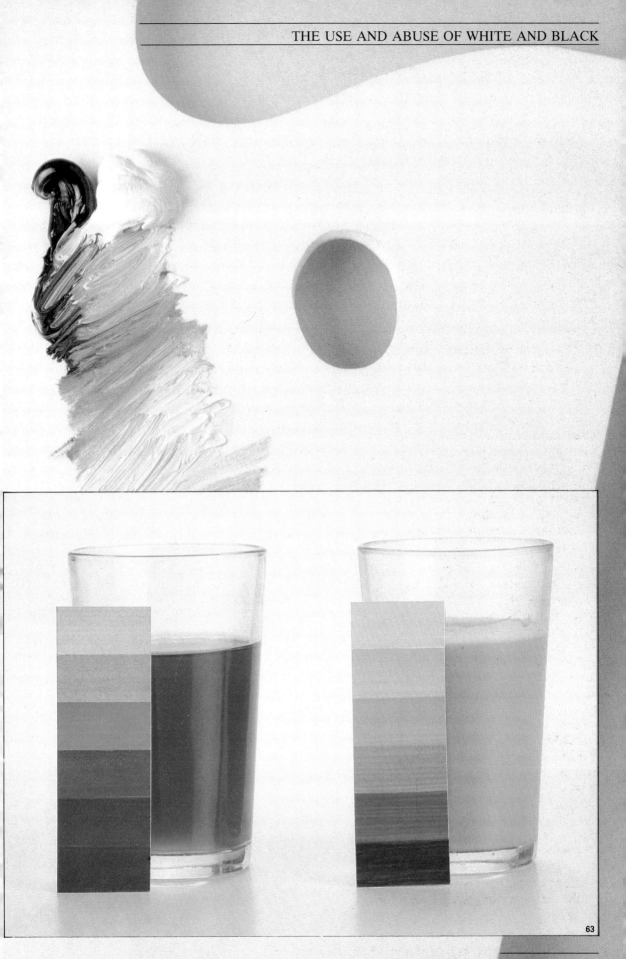

The color gray is 50% black

You will see that the use of black is just as dangerous as the use of white. Take a bright yellow, such as the primary pigment color, and darken it by adding black. Notice what happens:

When I mix the yellow with the black, the yellow becomes dirty, a gray. As I gradually blend in the black, it gives me a shade that is clearly green, a dirty green, which in no way corresponds to the idea of darkening the yellow.

In order to banish this error once and for all, you have to imitate the mixtures created by light in nature itself.

Indeed, the solution is to be found in the spectrum of colors itself. In the case of yellow, for example, you can see in the spectrum that the darkness comes from the red side. As the reds are transformed into oranges, they gradually become lighter until they reach the color yellow . . . and then it blends with the greens and the blues (figure 64). So, if you were to break down the range of the color yellow, you would begin with black, then a violet red, an orange sienna, a sienna, an orange yellow, a dark yellow, a neutral yellow, a lemon yellow (a mixture of yellow, green, and white), and finally a white (figure 65).

To confirm this theory, figures 66 and 67 show a graphic example of how to lighten and darken the color yellow.

64

65

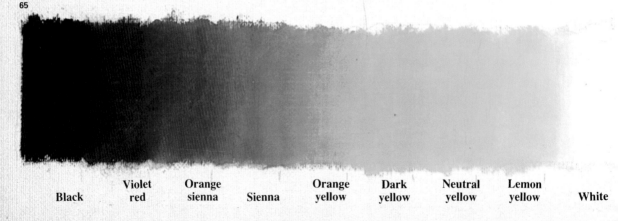

| Black | Violet red | Orange sienna | Sienna | Orange yellow | Dark yellow | Neutral yellow | Lemon yellow | White |

Fig. 66. BAD: The abuse of white and black is shown here in the overall graying of the color yellow. The painting is also spoiled by the green tones that appear in the shadows. This is a good example of what not to do when painting with opaque colors.

66

Fig. 67. GOOD: This painting is quite different. When you use all the colors of the spectrum to darken and lighten the yellow quality of the model, it acquires a greater realism and, most of all, a greater richness in its color.

67

Painting with the colors of the spectrum

The range of colors provided by the solar spectrum shows you the best mixtures to use to lighten and darken the primary color, cyan blue. You can see for yourself, in the diagram of the spectrum, that on the light side, the blue is verging on green. While on the dark side, it ends in an intense, dark blue leaning toward violet, which is represented on color charts by *ultramarine blue*. So you can see that in a breakdown of the color blue, there is a greenish tendency (a bluish green) in the light parts, a neutral tendency in the center, and a violet tendency, a blue that includes purple, in the dark parts. It is even possible to see in the darker parts a deep violet before you reach the totally black zone.

Now I will compare the subject of a jug and some blue flowers, first painted only with blue, black, and white, and then with all the necessary colors required for the subject (figures 70 and 71).

68

69

| Black | Violet blue | Ultramarine blue | Cobalt blue | Greenish blue | White |

Fig. 70. BAD: A blue subject, painted exclusively with blue and mixed with white and black, gives an image like this one. It has poor coloring; there is a predominance of grays that make the true color of the objects ugly and false.

70

Fig. 71. GOOD: Here is the correct version, painted with a range of blues like the one illustrated in figure 69. Compare this image with the previous one (fig. 70). Analyze the coloring of this picture, and you will see greens, different blues, purples and violets, as well as black, which emphasizes the subject and gives it life.

71

Finally, here is a breakdown of red, using the colors of the spectrum as a model once again, with black. There must be a mixture of black and violet, followed by crimson, red, orange red, orange yellow, pink (pink, yes, but one that is lightly tinged with yellow, as you will see, since this is the color that borders on red in the spectrum when the red becomes lighter), followed finally by white (figure 73).

The painting of tomatoes, with the use of only red, black, and white in figure 74, and with the use of all colors in the red spectrum in figure 75, shows you once again that it is best to "make white vanish as much as possible."

In short, the important thing is to discover the chromatic structure of a color as it lightens and darkens. This tendency, as you already know, may be influenced by the color of the objects themselves, the tonal color, and the reflected color, which are conditioned, in turn, by the color and intensity of the light and the intervening atmosphere. Keeping these factors in mind, you have to judge if the light areas lean toward yellow, red, or blue. Then you must proceed accordingly, completing the mixture by adding white. As far as the dark areas are concerned, you must remember that:

> **Black, in itself, is not enough to represent a lack of light.**

72

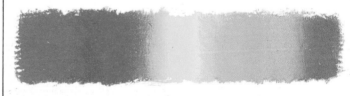

73

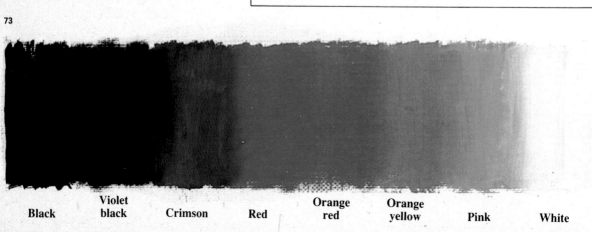

| Black | Violet black | Crimson | Red | Orange red | Orange yellow | Pink | White |

Fig. 74. BAD: Yes . . . Judging by the shape and the drawing, these are tomatoes. But not really. Tomatoes don't have that dirty brownish color, or that grayish red. This is a poor example painted by an amateur with no experience, who just lightened the red with white and darkened it with black.

74

Fig. 75. GOOD: These are tomatoes! By mixing red and yellow (and white, of course), red and crimson, and blue and sienna and green, the true color of the subject was produced. This is a perfect example of the solar spectrum, and the breakdown of red reproduced in figure 73.

75

The following chapter deals with the selection of colors—twelve altogether, plus white and black—that are generally used by professional artists. There is a brief study of each color with its tendencies and variety of shades, which are taken on when mixed with other colors. You will see visual examples of these mixtures with their results. You will also read commentaries on the results obtained by mixing; for example, a cobalt blue or a Prussian blue mixed with other colors. I think this is a useful lesson and suggest you put it into practice. In other words, it would be a good idea for you to try these same mixtures, experimenting while learning the contents of the text and the illustrations of this chapter.

76

COLORS
—COMMONLY—
USED BY ARTISTS

Twelve colors are enough

For the purpose of this study, I have chosen a selection of oil colors. Oil is the king of paints, from which the names, definitions, and classifications used in other mediums such as watercolor, tempera, pastel, colored pencils, and so on have been established.

In figure 77, you can see a selection of the most widely used colors. But remember that the color charts prepared by oil paint manufacturers include a far greater number of colors.

The enormous color range used by the manufacturers respond, first, to the artist's need and ability to choose the colors he considers to be in current use, and second, to the opportunity to choose and extend the normal range with one or more special colors.

I give a total of fourteen colors—including black and white—which are considered the most widely used. But I should also mention that this range can be reduced to ten colors only.

To give you an idea of this smaller selection, I have marked the ten most necessary colors with asterisks. Therefore, if you had to reduce the color range, you could do without the other four colors.

Speaking of this list, let me now try to answer an earlier question. The amateur found it strange that, since it is possible to compose all colors just with the three primary colors—cyan blue, magenta, and yellow—why should the artist make his life and his palette more complicated by using any more?

Well, in the first place, as you can see merely by going through the color range, yellow, red, and blue clearly predominate.

And so, in theory, the primacy of those three colors remains intact.

I should also say that this type of color range, used by someone who knows what he is doing, makes the task of mixing and composing colors infinitely easier.

If you were painting with just the three primary colors and wanted to obtain a yellow ochre, for example, you would have to mix blue and yellow in unequal proportions and then add a little white to the mixture.

In short, each of these nonprimary colors has a particular color tendency, extremely difficult to obtain if it has to be imitated with a mixture of primary colors. Chemically, this imitation is not possible, because the chemical composition of each color is different. Yellow ochre, for example, is composed of specially composed natural earths; while in blue, there is iron ferrocyanide; in purple, there is cochineal lacquer; and in yellow, there is cadmium sulphate. These three chemical compounds, no matter how they are mixed, cannot give the exact shade supplied by the chemical composition of yellow ochre.

In the following pages, you will see a brief study of each of the colors in the chart on the opposite page. There is also a discusion about the shades and qualities of each color when they are mixed with other colors. The study proves that it is practical and necessary to paint with more than three colors.

OIL COLORS COMMONLY USED BY ARTISTS

Cadmium lemon yellow	Permanent green
Cadmium yellow medium*	Emerald green*
Yellow ochre*	Ultramarine blue deep*
Burnt sienna	Cobalt blue deep*
Burnt umber*	Prussian blue*
Light vermilion*	Titanium white*
Deep madder*	Ivory black

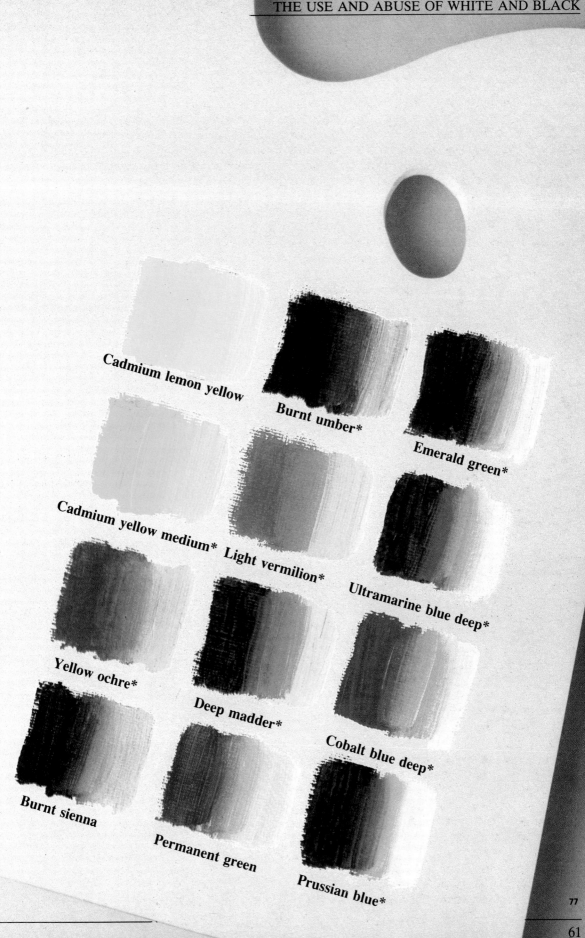

Cadmium lemon yellow

Burnt umber*

Emerald green*

Cadmium yellow medium* Light vermilion*

Ultramarine blue deep*

Yellow ochre*

Deep madder*

Cobalt blue deep*

Burnt sienna

Permanent green

Prussian blue*

A study of the colors

This study refers to common colors. For the most part, these tones and shades are common to any class of color media. In any box of watercolors, tubes of tempera, or case of pastels or colored pencils, you will find the same cadmium yellow light, yellow ochre, cobalt blue, ultramarine blue, and so on. They are manufactured with the same shade, or one very similar, and they usually have the same name.

Titanium white

There are generally three classes of white in oil painting, classified by the names *silver white, zinc white*, and *titanium white*. It is useful to know that *silver white* is more opaque, covers more and dries more quickly than the *zinc white. Silver white* makes it possible to achieve more texture, with paint made from thick pastes, but the disadvantage is that it causes cracks or fissures because of its thickness. *Zinc white* is more transparent and more fluid, but it dries much more slowly, which makes it difficult to work on a painting while it is drying. The composition of *titanium white* is somewhere between the two, which is why it is more widely used than the others. In any type of opaque media, such as oil, tempera, or pastel, white is often used, because it is a part of most mixtures. This is why white paint is manufactured in large tubes (figure 78).

NET CONTENTS
MIXED WHITE (TITA
BLANC MELANGE (TI
GEMISCHTES WEISS
GEMENGD WIT (TIT
+++ 103 SERIE

78

79

PERMANENT GREE
ERT PERMANENT
RMANENTGRÜN D
MANENTGROEN
+++ 619 SERIE

VIRIDIAN
VERT ÉMERA
ROMOXIDGRÜN
VERT ÉMERA
+++ 616 SERIE

COBALT BLUE L
BLEU DE COBALT
KOBALTBLAU H
KOBALTBLAUW U
+++ 513 SERIE

ULTRAMARINE
OUTREMER FO
LTRAMARIN D
ULTRAMARIJN D
+++ 506 SERIE

PRUSSIAN BLUE
BLEU DE PRUSS
PREUSSISCHBLA
PRUISISCHBLAUW
+++ 508 SERIES 2

IVORY BLAC
NOIR D'IVOIR
ELFENBEINSCH
IVOORZWAR
+++ 701 SERIE

NET CONT. 17 ml
MADE IN APELDOORN HOLL

NET CONT. 17 ml
BY TALENS PB 4 APELD

NET CONT. 17 ml
MADE IN APELDOORN HOLLA

NET CONT. 17 ml
BY TALENS PB 4 APELDO

NET CONT. 17 ml
ADE IN APELDOORN HOLL

NET CONT. 17
MADE IN APELDOORN HOLL

Yellows

**Cadmium lemon yellow
and cadmium yellow medium**

Look at the two yellows coming out of their tubes (figure 80) and notice the marked difference in shade between them. The cadmium lemon yellow (figure 80 A) is lighter, with a slight greenish tone; the cadmium yellow medium (figure 80 B) is darker and leans toward orange. These tendencies confirm the lesson in the previous chapter (see figure 65), where it is explained that, because of yellow's placement in the spectrum, a light yellow leans toward green and a dark yellow leans toward red.

As you paint, you have to remember these basic differences because, as you shall see in a moment, a yellow (or the color you happen to be using) mixed with other colors will always reflect the original yellow or color used.

Let us begin by looking at figures 81 and 82; these yellows are mixed with white. In the cadmium lemon yellow, the color is maintained (though it turns imperceptibly toward green); but with the cadmium yellow medium, the original color is altered to a creamy color. Then note that by mixing *cadmium lemon yellow, ochre, white,* and *red,* it is possible to obtain a wide range of flesh colors (figure 81 A).

Next, notice the mixture of cadmium yellow medium with red and crimson; you can see that the cadmium yellow medium takes the brilliance away from the oranges, particularly when mixed with *madder* (a crimson shade) (figure 82 A).

But the influence of each color is the most noticeable in the mixtures of *emerald green* and the three blues: *cobalt, ultramarine,* and *Prussian.* Study these parts of figures 81 and 82. See how the cadmium lemon yellow achieves a luminous variety of greens—light and brilliant; while in the mixtures with the cadmium yellow medium, the greens are browner.

Note, too, that when the greens are mixed with *cobalt blue* and *ultramarine blue,* they become gray; the reason for

this is that the blues are complementary to the yellows (figure 81 B). The mixture that goes the darkest is the ultramarine blue mixed with the cadmium yellow medium (figure 82 B), which confirms the general rule that, when mixed, complementary colors produce black.

Study all these effects. Remember in future the possibility of "illuminating" with the cadmium lemon yellow or "darkening with golden oranges" with the cadmium yellow medium. Keep in mind the different ranges of greens; the fact that to obtain a light, bright green, you have to use cadmium lemon yellow; to achieve golden, sap greens, use the cadmium yellow medium. Remember, too, that these green-greens are best obtained with *emerald green* and *Prussian blue;* since *ultramarine blue* is the complementary of yellow, it will give you dirty, grayish greens.

80

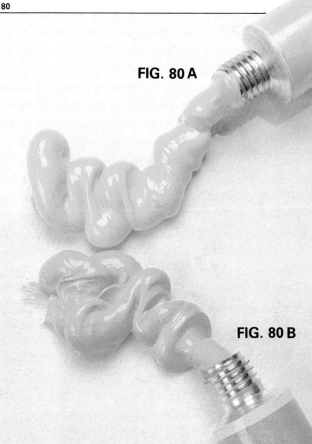

FIG. 80 A

FIG. 80 B

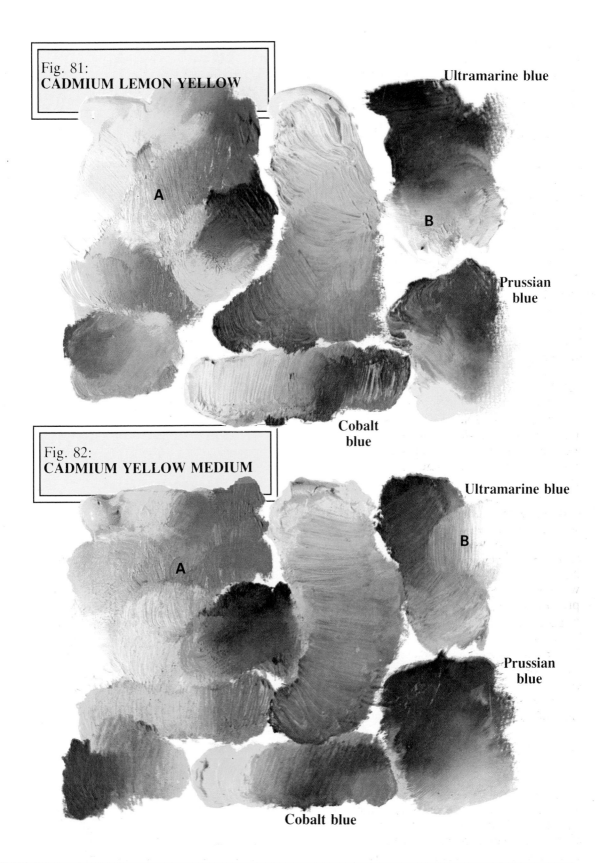

Fig. 81:
CADMIUM LEMON YELLOW

A

Ultramarine blue

B

Prussian
blue

Cobalt
blue

Fig. 82:
CADMIUM YELLOW MEDIUM

A

Ultramarine blue

B

Prussian
blue

Cobalt blue

Ochre and siennas

Yellow ochre and burnt sienna

By mixing yellow ochre and madder (a crimson shade) and a little white, you can obtain burnt sienna (figure 84 A); and by mixing burnt sienna with yellow and a little white, you can get yellow ochre (figure 84 B). These are two similar colors, with the difference being the tendency of one toward yellow and the other toward crimson. This similarity affects the mixtures of these colors with other colors. In mixtures with ochre, yellow will appear. With burnt sienna, the tendency will be toward a red, or crimson.

Both colors contain white; there is more in the ochre than in the burnt sienna. And both colors contain blue, which means that the two colors can turn gray. In figure 84 C, you see that the ochre mixed with white and red gives a flesh color.

When ochre is mixed with red or a crimson shade, a range of earth colors and siennas, essential to an artist's palette, is obtained.

Mixed with emerald green, the ochre produces brownish but luminous greens, as it does when mixed with Prussian blue—although with this mixture a darker green is obtained.

Finally, when mixed with cobalt blue and ultramarine blue, yellow ochre produces grayish browns.

Now look at the mixtures obtained with burnt sienna: the salmon color produced by the addition of white (figure 85 A); the monotone that comes from mixing it with yellow, red, and crimson; and the richness of the gray tones obtained by mixing it with emerald green and blue (figure 85 B). Notice that with emerald green (its complementary color), black or a darker tone is produced (figure 85 C). From these colors with the variants provided by the cobalt and ultramarine blues, a very rich range of grays and browns is obtained, which is essential for painting shadows—areas that are not completely black.

Raw sienna

This color is similar to yellow ochre, with the only difference being that it is darker within the same shade.

When raw sienna is mixed with white, yellow, and red (figure 86 A), you can obtain a wide range of flesh colors.

Raw sienna can also be darkened by graying. When mixed with blues, you can produce an excellent quality of greenish grays (figure 86 B).

83

FIG. 83 A

FIG. 83 B

FIG. 83 C

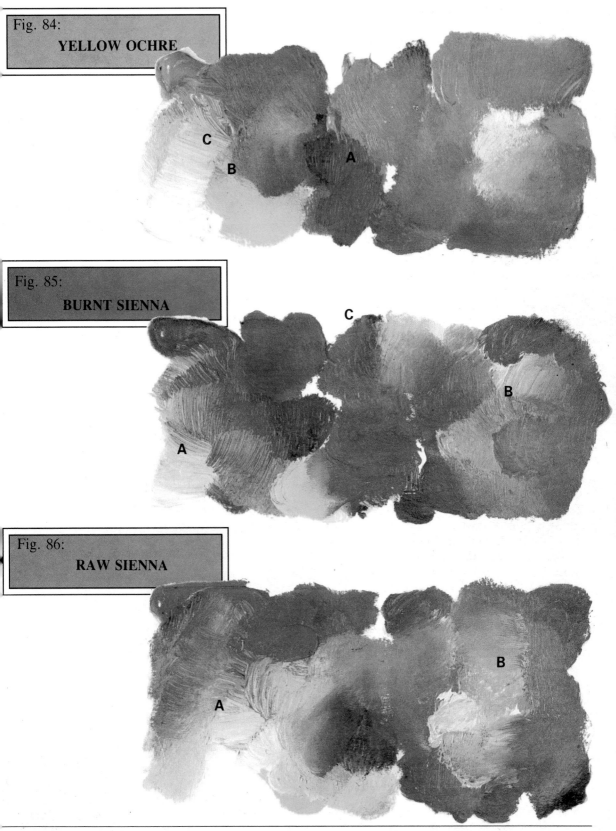

Fig. 84:
YELLOW OCHRE

Fig. 85:
BURNT SIENNA

Fig. 86:
RAW SIENNA

Red and crimson

Cadmium red and madder

When you compare these two colors, you'll notice the marked bluish tendency of madder (or crimson)—a primary color that cannot be reproduced with other colors (figures 87 A and B).

You have already seen the results these colors give when mixed with yellows and ochres (figures 81, 82, 84, 85, and 86). However, it is worth examining these brushstrokes of madder combined with lemon yellow and white (89 A). They provide a wide range of flesh colors, creams, oranges, and reds, which are very useful for darkening. Also note the luminous pink produced by the mixture of white and madder (89 B).

As for the mixtures with greens and blues, both the cadmium red and the madder can be darkened when mixed with emerald green—since this is their complementary color, especially for madder.

In the area indicated as C, where the black is darkest, you can see that the madder has been mixed with emerald green and burnt umber (be careful not to confuse burnt umber and burnt sienna). Make a note of this combination for obtaining a perfect black.

> **madder + emerald green + burnt umber = black**

This deep black seems more perfect than black itself. It is a black that has a certain tendency toward crimson, green, or brown; a black that is probably more in tune with the dominant *coloring* of the model—greenish, crimsonish, brownish—within a black *toning*.

Let us now consider violets and purples obtained from mixtures of red and madder with blues and a bit of white. Violets and purples aren't as clean when they are composed using red rather than madder. In the violets and purples obtained from madder, the col-or is cleaner; the purples appear transparent even in the shadow areas (D).

Finally, notice how the mixture of madder with Prussian blue produces a violet almost as dark as a black (E).

To a certain degree, this black is the result of the rule of complementaries: Prussian blue has some green coloring, and green is the complement of madder.

87

FIG. 87A

FIG. 87B

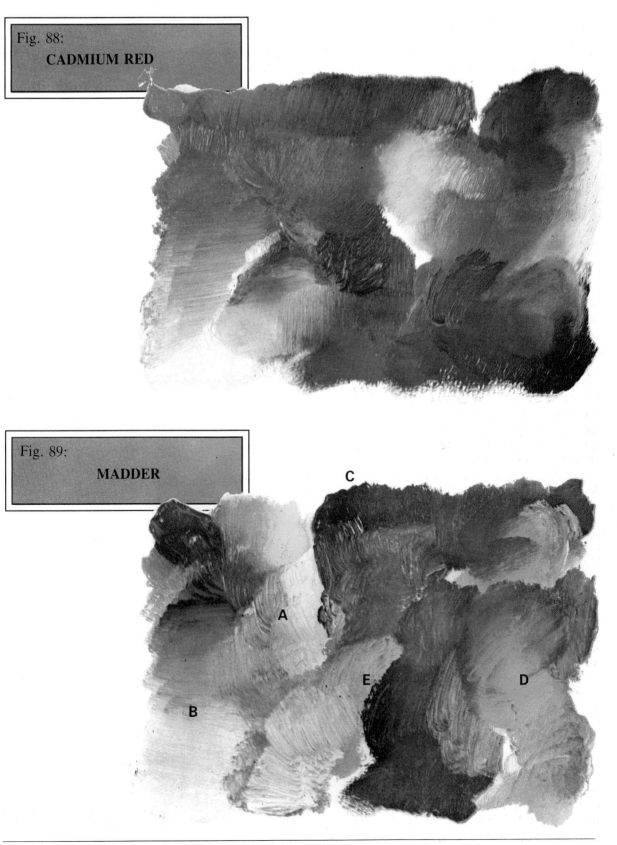

Fig. 88:
CADMIUM RED

Fig. 89:
MADDER

Burnt umber and emerald green

Burnt umber

Burnt umber is a color similar to black, with the only difference being that it has an earthy, dark brown shade. This shade is visible in mixtures with white and yellows (figure 91 A).

Notice the peculiarity of these colorings: the burnt gray when the umber is mixed with white; the yellows that turn toward a sour green, a kind of yellowish olive green.

Burnt umber should always be on your palette. It is not only indispensable for obtaining black; it is the ideal color for breaking up strident strokes, and the best color for producing grays (91 B). While this color may be a danger in the hands of an inexperienced painter, it is an invaluable instrument in the hands of a professional, who is capable of using it in the right measure, taking into account that it is a necessary color and a useful substitute for black—without being completely black.

Because burnt umber is an eminently dark color, it is easy to use it to compose another perfect black based on this combination:

> **burnt umber + madder + Prussian blue = black**

This black, as you may have realized, gives the artist a chance to enhance a bluish or purple tint that may be in the coloring of the model.

Emerald green

As with the other primary colors, green is a necessary color.

The emerald *tonality* has a slightly bluish green, which is useful in obtaining a wide range of greens in combination with yellows. You can also produce a range of green blues by mixing cobalt, ultramarine, and Prussian blues.

Mixed with white, it gives a bluish green color (92 A), which, when mixed with lemon yellow, makes a fine luminous quality of pale greens.

With the blues and white, this color gives rich ranges of bluish greens, which when mixed with yellows can produce all known and possible greens. It also produces velvety blacks in combination with burnt umber, madder, and Prussian blue (92 B). It is a color that appears transparent in many light and dark shadows; a color that is present on the palette of every expert artist.

In short, emerald green is the only green you need to obtain all imaginable greens.

90

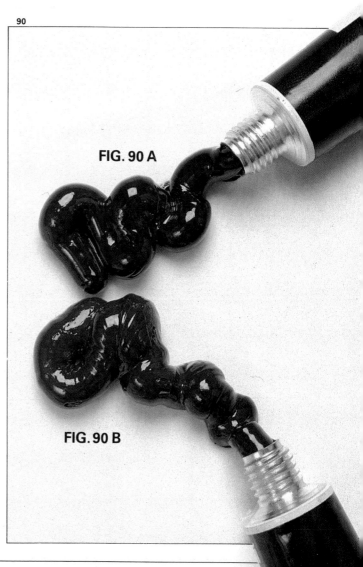

FIG. 90 A

FIG. 90 B

Fig. 91:
BURNT UMBER

Fig. 92:
EMERALD GREEN

Blues

Cobalt blue deep, ultramarine blue deep, Prussian blue

In order for you to distinguish the characteristic shades of each of these blues, I have broken them down with white and then mixed them with madder and a little white to make three violets.

Cobalt blue deep, a blue blue

The proof that cobalt, a luminous and transparent color, is the finest "blue blue" is that it always appears in shadows. Imagine a radiant whitewashed wall in full sunlight; if you examine its color structure, you will find that the shadows on the wall, whether they are gray, blue, or violet, will include cobalt blue in their composition. Picture a stain of luminous blue—a light blue—placed in nature, bathed in sunlight, in full radiance, and you will see cobalt blue appear again. It is a neutral color blue, made of light and brightness.

Ultramarine blue deep, a violet blue

A gray obtained with cobalt blue deep and a gray obtained with ultramarine blue deep can be differentiated because the latter shows a tendency toward crimson. This justifies the use of ultramarine blue deep in any opaque or dark shadow. But first you must see if the blue, or the dark parts that require blue, in your subject have a tendency toward the *neutral blue* of cobalt or the *violet blue* of ultramarine.

Prussian blue, a radiant blue

This is a very intense blue that can dominate another color, but can also, if used with caution, produce extraordinary transparent shades.

In combination with white, it has the quality of graying and, at the same time, of illuminating any color. Remember when you paint dark tones or tones in shadow not to abuse it. Mix it with other blues.

* * *

And black? Is there no black in oil colors?

Yes, there is, but why run the risk of graying and dirtying everything? When it can be better obtained, with a finer color sense, by mixing crimson, burnt umber, emerald green, and Prussian blue?

In any case, it can be said that ivory black used with care is a useful, even magnificent, color.

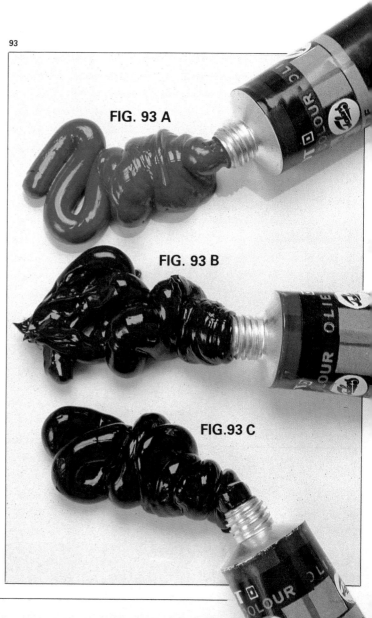

93

FIG. 93 A

FIG. 93 B

FIG. 93 C

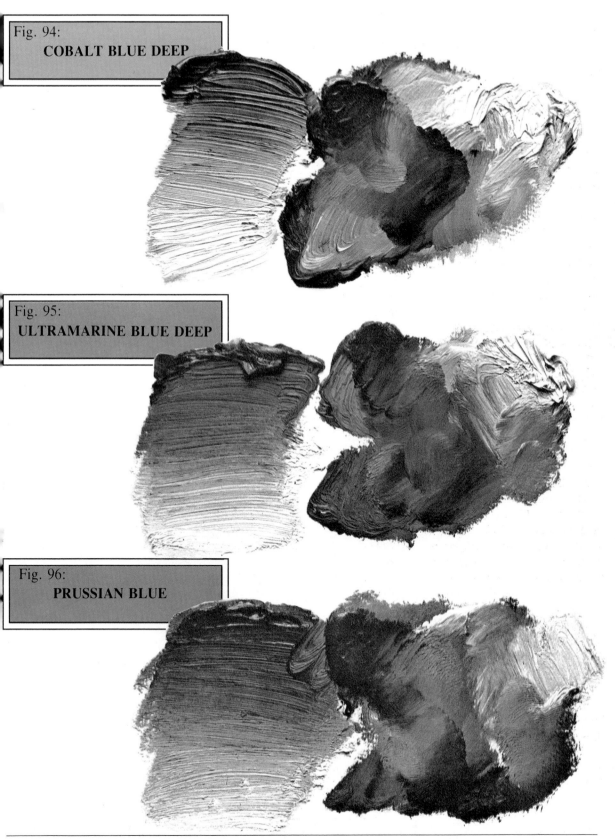

Fig. 94:
COBALT BLUE DEEP

Fig. 95:
ULTRAMARINE BLUE DEEP

Fig. 96:
PRUSSIAN BLUE

Van Gogh once said, "Look for the blue in all shadows." This is the main focus of the next chapter: the color blue is always present in the color of shadows. At one time, the basic color for shadows was asphalt, a color similar to the present-day *Van Dyck brown* or *burnt umber*. Today, the basic color for shadows is blue. The second factor, or basic lesson, of this chapter is the fact that in the color of shadows, there is always the complementary of the color itself. This was discovered by the post-impressionists and the fauvists, and I would like you to try and test it for yourself: paint a green meadow, and then paint the projected shadow of any object: a tree, a post, or a wall. Remember that the complementary color of green is magenta, or crimson; so that by mixing green with crimson, a little blue, and perhaps a touch of white, you can obtain a perfect luminous, transparent shadow color. Take advantage of the following lesson —it is very important.

97

THE COLOR
OF
SHADOWS

How to paint the color of shadows

The color of shadows may be one of the most difficult aspects in painting. To make this lesson more effective, I included a series of the same subject matter, examples that I painted in various colors. With each full-color example is an explanation.

As I was painting, I wondered, "What color is it?" When I painted the color of each object—the illuminated part of the dish, the apples, the tablecloth, and so on—the answer was not difficult. The problem, even though it was a problem, was not a hard one. The dish was greenish yellow; the apples were crimson red, with yellow parts or stains; the cloth was white. . . . Whether the color of the dish or the yellow of the bananas are only slightly different from those of the actual model is of no importance. It is well known that no one sees colors the same way and that, moreover, each artist has his own personal preference, his own particular chromatic tendency. Ah, but what needs to have a perfect *coloring relationship*, where there is no room for variation, is the color of shadows. If you are capable of painting real shadows, ones with a perfect relationship between the local colors and the tonal and reflected colors, you can say that the art of painting holds no more secrets for you.

Well, from now on, when you run into the problem of coloring the areas in shadow, remember that in the color of any shadow, there is always a mixture of the following colors:

THE COLOR BLUE, PRESENT IN ALL DARKNESS,
mixed with
THE LOCAL COLOR IN A DARKER TONE,
in turn mixed with
THE COMPLEMENTARY, IN EACH CASE, OF THE LOCAL COLOR.

To make the application of this formula easier to understand, I will show you how I painted the subject, but in a way that will certainly seem strange. In the following pictures I will try to show you why three colors are necessary to paint the color of shadows. Let us first study the presence of the color blue in any shadow.

Blue is present in all darkness
When the intensity of natural light diminishes, it turns bluish and gives a blue shade to all surrounding colors. You only have to look at a landscape at dusk to realize that all the surrounding objects lean toward a dark blue; all the surrounding colors appear to be mixed with blue; and *then finally everything is blue*.

In figure 99, note the large amount of blue in the subject. Notice that not even the local colors, such as ochre, the crimson of the apples, or even the white of the cloth, escape this blue influence. Notice, especially, the intensity of the blue in the areas in shadow. Do not forget:

In theory, a shadow is blue.

By looking at the model, decide for yourself whether the blue must be clean and neutral, like cobalt; greenish, like Prussian; or violet, like ultramarine. You can easily judge if the shadows have a neutral, green, or violet tendency, because the cobalt and Prussian blues will illuminate the shadows, while ultramarine blue will have a tendency to turn the shadow gray, to take away color.

Fig. 99. Here is an example of the part the color blue plays in all the colors of the model and, especially, in all the colors of the shadows. Bear in mind the influence of the color blue and you will find almost no need to analyze the color of the model. It is an absolute requirement to mix blue into the tones and colors of shadows.

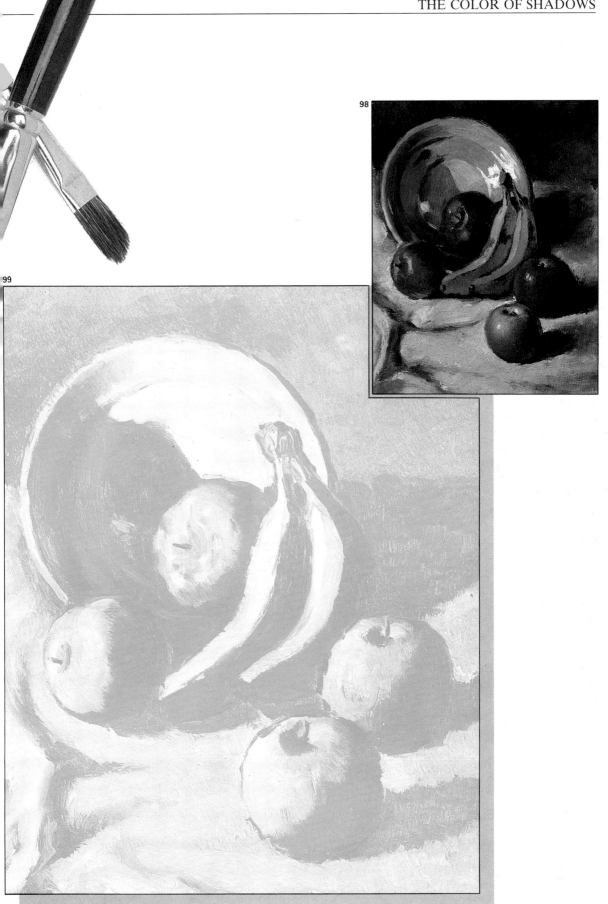

98

99

The local color in darker tones

When I spoke of the "use and abuse of black" to make a color darker, I said that this darkening *must be based on a spectral gradation*. This is a process of breaking down and darkening with colors, rather than with only black, which, as I said then, does not darken the color—it dirties it. I will be referring to this process now when I discuss the color which is present in all shadows: *the local color in darker tones.*

You already know what I mean by the *local color*. It is the true color of the subject, the red of a red tomato or the yellow of a banana. Then you will also know what I mean by the *local color in darker tones*. In these bananas, for example, the local color in *darker tones* could be a yellow ochre or a reddish sienna or a dark umber, and so on. (To make this clearer, look at the breakdown of the color yellow, on page 52.) In figure 100, you can see the result I obtained after painting the still life of the dish, the bananas, and the apples with the local color in darker tones.

Take the colors I painted the ceramic dish: in the areas that receive light, a yellowish ochre; in the areas in shadow, the local color, but in a darker tone—the result of which is a light sienna. In the bananas, while the areas that receive direct light show a strident yellow, the areas in shadow are represented by the same yellow, but in a darker tone—an orange ochre. The same may be said of the apples, and so on.

Observe, also, the overall consistency of the reflected colors in the illustration. It is an important part in the play of light and shadow.

The result is plain to see. By darkening the local colors of each object, volume and relief is achieved in each object—but they never manage to supply the intrinsic qualities of the colors in shadow. As you may have guessed by now, this is not the ideal result.

To fulfill this ideal, these colors in shadow need to be mixed with blue as well as the complementary color of each local color. This is a factor that we will continue to study.

But, first, notice the rather antiquated appearance of this painting, where I used only a *local color in a darker tone*. This coloring is somewhat reminiscent of an old master's painting . . . with an abundance of sepia colors in the shadows . . . before the discovery that revolutionized the whole technique of painting: the rules of using complementary colors.

Fig. 100. Here you can see the darkening of the local color in the shadows. It is a darkening of the local color within a spectral range. You can also see that although the objects painted within this range take on volume, for the best results, they need the presence of the color blue and the complementary color of each object's local color in their shadows.

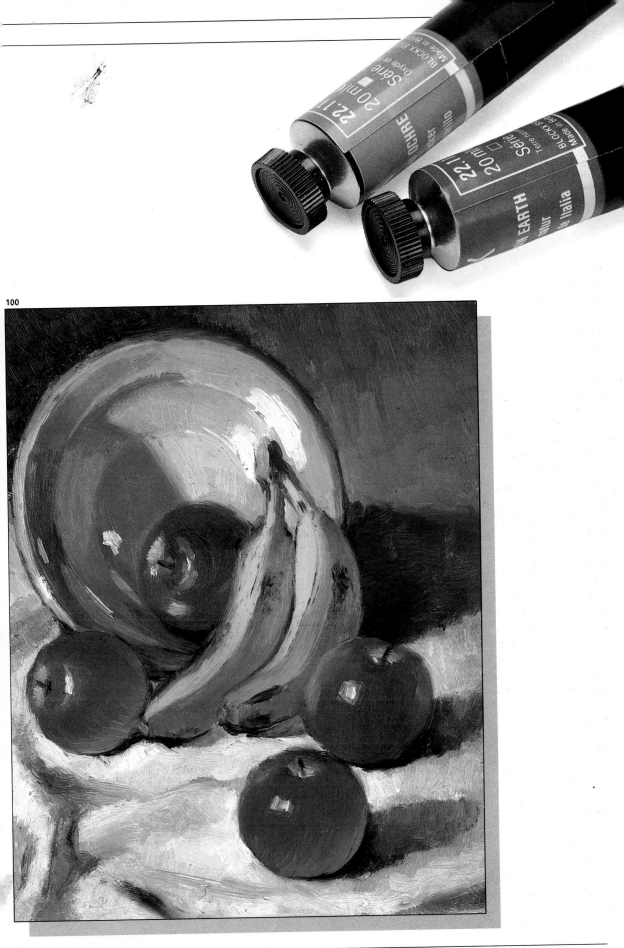

100

The complementary color of the local color

The very essence of post-impressionism and fauvism, with regard to color, lies in painting a shadow with the complementary colors of the local color in an object. I created this painting of the dish, the bananas, and the apples with this theory in mind, but carried it to its limit (figure 101). Here, I also tried another impressionist technique; by not worrying about formal exactness, I emphasized and brought out the contours of the objects with black outlines (in the style of some paintings by Toulouse-Lautrec, Cézanne, and especially van Gogh). The objects are represented in large stains or planes of color, with a tendency toward a light, luminous coloring. (I painted the background colors, the cloth and the dish, with lemon yellow instead of a greenish yellow.)

There is no doubt that this picture was painted with the formula of complementary colors in the shadows, which gives it an extraordinary contrast and luminosity. This is a natural process because this contrast originates from the juxtaposition of the most opposed colors—the colors that offer the greatest contrast, or the complementary colors. Also, this juxtaposition, through the "induction of complementary colors," which I discussed on pages 44 and 45, produces a color enhancement carried to the maximum.

The impressionists knew how to take advantage of this process to create genuine symphonies of light and color in their paintings. Keeping in mind the ideas behind complementary colors (juxtaposing them, using them in shadows, and painting with maximum color contrasts), you can also take advantage of these ideas and paint with greater mastery.

I am not advising you to paint like this, with violent contrasts, but I think you should remember these lessons, in order to achieve a more up-to-date, more contemporary conception of painting. I recommend that you move toward this luminosity, this joy of color that comes when you know how to bring the complementary colors into play. The successful pictorial effects produced by violent color contrasts leave no doubt that this is a necessary formula that must be present in every combination of shadow and light. By combining all these factors, you will approach the true color of shadows. Now I will analyze the finished work:

Fig. 101. The shadow in this picture were painted with the complementary color of each local color. (For example, the shadow of the yellow dish, with its complementary blue; the crimson apples, with their complementary, green.) The result of this experiment is a painting with a color contrast and luminosity in the shadows, which are truly extraordinary. It prove the need for complementary colors in shadows, and it demonstrates the influence of this formula in impressionist painting.

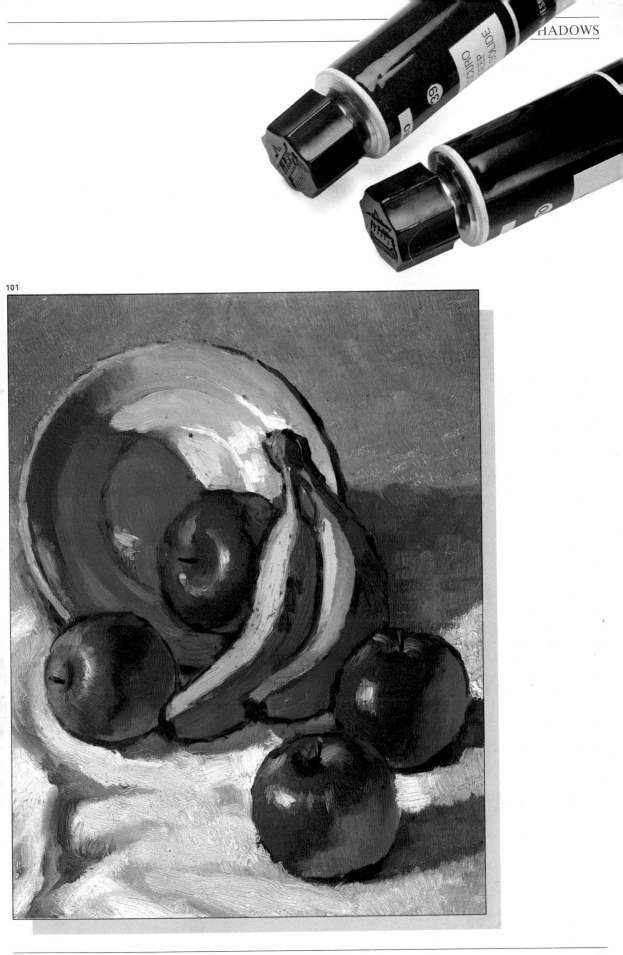

101

The finished painting

In figure 102 is the finished painting, which was painted with three colors.

Color A: Blue. Note the amount of blue evident in all the shadows of the painting, beginning with the shadow projected by the objects onto the cloth. There is a decisive influence of blue in the shadow of the ceramic dish. Now go back to the color example of this shadow in figure 100 and try to mix that tone with the blue of the same shadow represented in figure 99. You'll see when you mix the blue color and the other color, light sienna, that almost without any help from the complementary color (which is also blue), the color of the shadow of the dish "comes out" a greenish ochre shade . . . composed of ochre and blue. Look at the colors in the shadow of the bananas and the apples in the same way.

Color B: The local color in a darker tone. Neither the blue color present in the shadow areas, nor the induction and influence of the complementary colors, nor the reflected colors of the objects can totally destroy the fact that you see, to a greater or lesser degree, the local colors of the objects. You have already seen an example of this in the red billiard ball in figure 32, in the lesson about *local color*. You saw then that however much the shadow is seen, the influence of the luminous red of the lights is still perceptible. In this painting, in the folds and parts of the cloth in shadow, there is still, in spite of the marked bluish tendency, the white of the cloth in a darker tone (a gray color that is perfectly visible in the shadows).

Color C: The complementary of the local color. In this final painting, notice the overall effect of the three factors or colors that are always present in the areas in shadow. In the shadow of the ceramic dish, besides the blue and the local color in a darker tone, there are some violet shades, which are produced from the complementary color. You can also see in the apples, in the shadow areas, the influence of the complementary of the red (green), which when mixed with the blue and the darker local color, produces this range of crimsons, siennas, dark brown, and even tones of old gold (as seen in the apple in the foreground). As you can see, complementary colors play a decisive role in the reflected lights of the apples, with an evident blue or green tendency (compare these tonalities with those painted in figure 101).

Fig. 102. Try to see, the colors of the shadows, the mixture these three basic factors you have just studied: the blue color, the local color in a dark shade, and the complementary color of the local color.

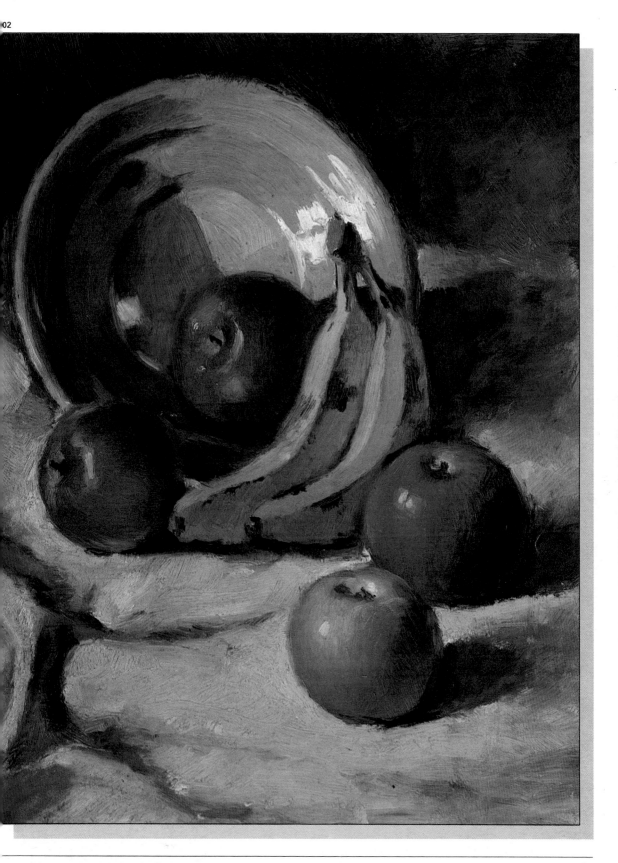

All painters have their own personal art gallery: a group of their paintings that they do not intend to sell, and that appear in catalogs as "collection of the artist." I too have some paintings—my own work—that I have no intention of selling. My favorite is one called *The Bridge on Calle Marina*, which depicts a city bridge trains arriving in Barcelona crossed by years ago. I like this painting because of its harmonizing colors in a broken range with a warm tendency. It has a "sad" range of colors, the colors of a poor district, of a slum. In fact, as I was painting it, I related it to a melody, a popular ballad from Galicia, a region of Spain. The song is about an emigrant who pines for his homeland. Maybe that is why the painting came out with a range of colors as vibrant as a Verdi aria, but as simple as a Gregorian chant.

In this chapter, I will discuss harmonizing colors, their ranges, and their relationship to ranges of sounds, such as cantos and arias.

103

HARMONIZING
——— COLORS ———

General principles of harmonizing colors

Figs. 104 to 108. Color harmonization is derived from nature. First thing in the morning, there is a bluish tendency; at midday, there is a predominance of yellow; in midafternoon, the color is gold, almost orange. The sun eclipsed by a cloud generally produces a range of broken, dirty, and gray colors. Tungsten artificial light is yellow; fluorescent light may be blue or green. The artist's task is to capture these tendencies and accentuate them in order to find a better color harmonization.

The need to study color harmonization is visible and obvious when you examine the paintings of the great masters. The colors were always planned in a way that cannot possibly be considered accidental—even when responding to what he saw in the subject, the painter had to bow to the laws and standards present in nature itself.

Consider, however, that at times artists paint from memory—creating, combining, and uniting colors with their imagination. How often have you been asked for advice along these lines: "You paint, you've got taste, what color would you put here?"

The following lesson will try to answer

that question and all questions about the art of harmonizing colors. Basically, color harmonization is given by nature itself. Whatever the subject may be, there is always a *luminous tendency*, which relates some colors to others and unites all of them as a whole. The classic example of this effect can be seen in a sunlit landscape when dusk is falling. Under those conditions, the sun rays color the fields with a markedly reddish or orangish tendency, which tinges all bodies with that color. This effect makes even the most disparate colors relate in some way to the other colors. If you look at the same landscape at another time of day at midday with a cloudy sky, with no

104

105

sun, the color tendency will be made up of the gray reflection of the half-covered or bluish sky. By the sea, the light and the colors are influenced by the blue reflection of the water and the sky. In high mountains, the light and colors are influenced either by the opacity of the mist or the translucent quality of a clear day. Artificial light also creates this luminous *tendency*, which filters colors in a particular way: ordinary artificial light is yellowish or orangish; fluorescent light is bluish or pinkish.

Your task, when you are painting a subject, is to discover the chromatic tendency and transfer it into the picture, taking maximum artistic advan-

tage of it. In both cases, you have to adapt and organize your palette in order to achieve the primary goal of harmonization:

> **Find the harmony of one color with another, or of various colors with each other, to establish a color range that gives pleasure to the spirit.**

This concordance of colors is based primarily on the knowledge and use of different *color ranges*.

106

107

108

The meaning of "range"

Music . . . painting . . . combination of sounds . . . combination of colors . . . an obvious analogy. However, little attention is paid to analyzing the laws of harmonization that govern painting. You will see that, along broad lines, they are comparable to the laws of music. The first and most important coincidence is in the word *range*.

In fact, the word *range* comes from the system of musical notes invented by Guido d'Arezzo in the twelfth century. He established the classic order of a scale of sounds represented by the notes *do, re, mi, fa, so, la, ti, do*. Considering that this system is perfect, you can say that:

> The word *range* originally meant a succession of sounds ordered in a particular way, which was considered perfect.

By analogy, in painting the word *range* applies to the succession of spectrum colors. This is based on the idea that this color succession, as it appears when light is dispersed, presents a perfect order. And so, it is not strange that by extending this concept, you can apply the term to any scale or ordered color succession, such as the ones you see on this page. For instance, the example of a *warm color range* (figures 109 and 109 A); a *cool range* (110 and 110 A); and a *broken color range* (111 and 111 A).

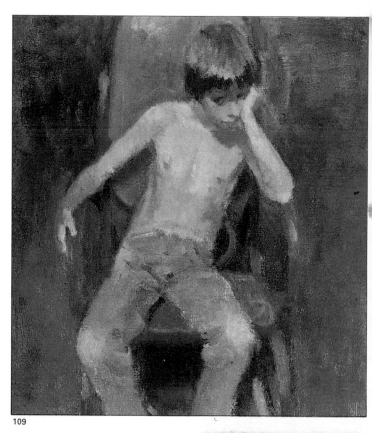

109

109A

110

111

110A

111A

The ranges of colors

I will now discuss the ranges of colors. In order to have a better understanding of how to apply this term to painting, you should look at the opposite page, figure 114. This is a reproduction of the spectrum, with its infinite variety of colors, tones, and shades; it is perfectly ordered and basically includes the primary, secondary, and tertiary colors. From left to right:

> **Magenta, crimson, red, orange, yellow, light green, green, emerald green, cyan blue, ultramarine blue, dark blue or purple, and violet.**

You should think about translating these colors into tones, for example, into a series of grays whose values are in accordance with the order and tonalities of the spectrum (figure 115). By doing so, you will also obtain a perfect succession of ordered elements; in this case, a range of *grays*.

In addition, you can see that the meaning of the word *range* can refer not only to the ordered succession of the colors in the spectrum, but also to *a part of the spectrum*—even to a single color of the spectrum broken down into a scale, or range, of different tonalities. Hence, you can come to the following conclusion:

> **RANGE is any succession of perfectly ordered colors or tones.**

Figs. 112 and 113. J. M. Parramón, *Fornells* (detail), private collection. Here is a classic example of a cool color range, with a predominance of blues and greens in the original colors. Below is the same painting reproduced in black and white, corresponding to the idea of a *range* as a succession of perfectly ordered colors or tones.

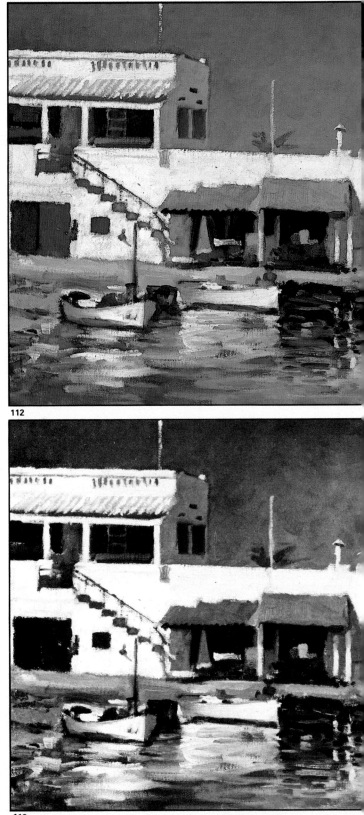

112

113

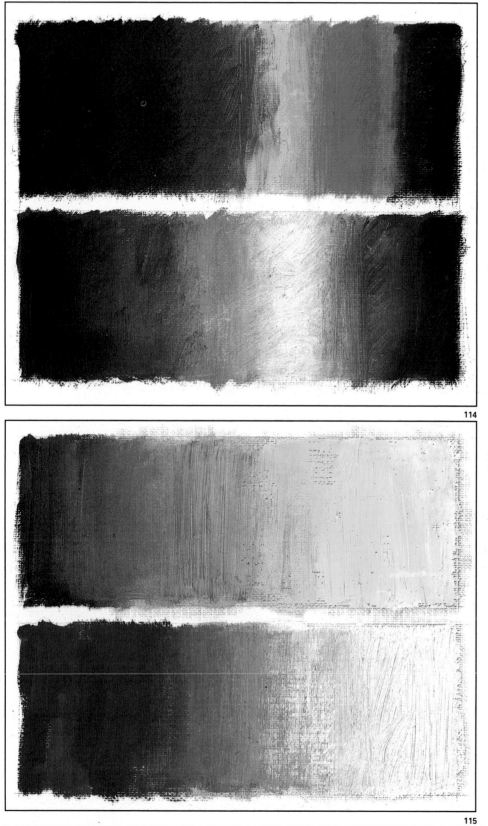

Figs. 114 and 115. The color range of the spectrum; below it is a range of ochres and yellows, which can be represented by a range of gray colors. The yellow and gray ranges correspond to the idea of a succession of perfectly ordered tones.

114

115

The ranges most often used in color harmonization

I will illustrate this lesson with the following images:

Figure 116. Here is a spectrum range, in the form of a circle, composed of the primary colors, yellow, cyan blue, and magenta (the triangles in high relief); the secondary colors, green, dark blue, and red (the triangles on the same level as the outer circle); and between each primary and each secondary color, the tertiary colors, light green, emerald green, ultramarine blue, violet, crimson, and orange (the triangles in low relief). Study the complementary colors in this table; they are easy to locate if you remember that they are always the colors in direct opposition.

Figure 121. In this palette, or range, you can see the mixture of each color in the spectrum range.

Figures 117, 118, 119, 120. Finally, here you have a chance to see and study various examples painted with each range of colors.

116

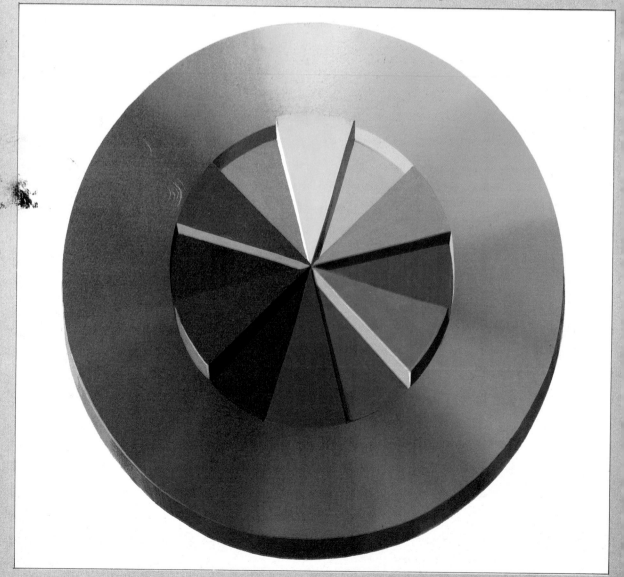

117

118

119

120

121

Melodic range

Let me begin with the first and simplest range, or harmonization:

> **The melodic range is composed of a single color, broken down into two different tones, and includes black and white.**

In figures 122 and 123, you can see examples of melodic ranges painted with an ochre-sienna color and black (left) and a blue and black color (opposite page).

The results obtained with a melodic range are surprising in spite of its simplicity. It shows you that it is possible to obtain a great wealth of shades, bearing in mind that the colors all originate from a single color, with the addition of white and black. In fact, the secret of the melodic range is based on properly administering the white and the black in relation to the color range (see the blue illustration). First, you must remember that by mixing white and black you produce a new color—a neutral gray—independent of the range color. And second, remember that both the white and the black, when mixed with a given color, will modify their shade to produce a somewhat different color. (Do you recall the lesson on pages 50 and 51, with the example of the black and white coffee?) This type of change in the color range can cause a lot of damage when you are doing a full-color painting. But in a monochromatic painting, such as the one on this page, it is highly beneficial and advantageous to use a range like this one. To corroborate these remarks, look at the palette range in figure 124. Notice how the tones were obtained only with the color blue. The color appears fully saturated when it is mixed with white. When it is mixed with black, it becomes a darker or lighter gray. Study carefully the overtly gray shades that are a product of black and white and the other shades; the

gray appears with a slight touch of blue.

Finally, look at the picture to see how this palette was applied.

The *melodic range* owes its name to the meaning of the musical term *melody*. Because, it is indeed the song . . . solo, with no accompaniment. It is the song you sing to yourself, the same song that vocalists sing, independent of the orchestra.

122

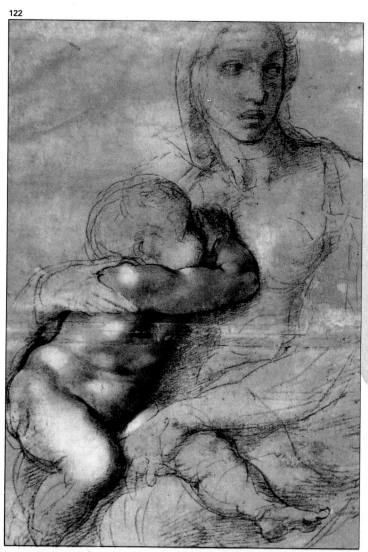

Figs. 122 and 123 (left). Michelangelo, *Madonna with Child*. Michelangelo made this drawing on a light yellow ochre paper. Drawing with sienna and black chalk and bringing out the whites with white chalk, he achieved a fine color harmonization. On the opposite page, you can see a portrait of Winston Churchill that I painted with black and blue watercolor, using also the white of the paper. This is another example of a color harmonization painted with a *melodic range of colors*.

123

A simple harmonic range

If you ask a musician what the term "harmonic chord" means, he will tell you that it is *the simultaneous, coordinated meeting of various sounds from which a new sonority is obtained.* Musical harmony, however, is subordinate to the singing voice for which it serves as an accompaniment. Therefore you can say:

> **A simple harmonic range is composed of a melodic or dominant color, "accompanied" by three other colors, of an opposite shade, that form a group from which a new coloring is obtained.**

The formula to follow is:

> **1. Choose a dominant color, according to the color dominance provided by the subject.**
> **2. Four colors away from the dominant color (moving from left to right in a circle of twelve spectrum colors) are three colors in the opposite shade, each of which, when mixed with its neighboring shade, produces the next shade.**
> **3. The last color in the trio is the complementary of the chosen dominant color.**

To understand this definition more clearly, look at the example illustrated in the center of the circle. In the spectrum range, you can see the colors used: orange as the melodic, or dominant color (the color that "sings," so to speak); and four spaces away, the emerald green, the cyan blue, and the ultramarine blue. When the "accompaniment" color is mixed with the previous color, it provides a new coloring —in this case, a greenish shade. In figure 126, you will see a *picture* painted with a simple harmonic range. Notice that in the *range palette*, you can also see the use of black and white (fig. 127).

As you can see in these illustrations, the wealth of the *simple harmonic range* is almost perfect. It contains (with the colors I already mentioned) every kind of blue, green, sienna, and orange shade; only one color is lacking (red in this case) to complete the range. The main characteristic is the *dominant color*, which must influence and be present in all the other colors, including the new coloring, which is the result of the total mixture.

In figure 128, you see that the color orange is, indeed, the *soloist*, the color that "sets the tone." It is present in all the subordinate mixtures, with which it achieves a perfect coordination.

Finally, since there is *such a direct play of complementaries in this harmonization, it is necessary for one color to predominate.* By doing so, you can avoid the worst of all evils in harmonization: the negation of color. In the following pages, I will discuss this important factor.

125

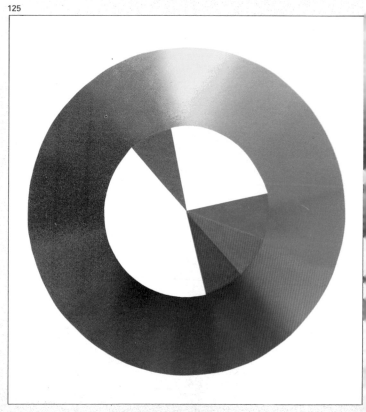

Fig. 126. Claude Monet, *Snow in Vétheuil*, Musée d'Orsay, Paris. This is a fine example of the possibilities in a *range of simple harmonic colors*, which, in spite of its apparent limitations, displays a plethora of shades.

127

128

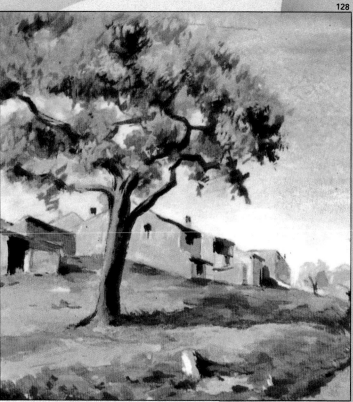

Harmonic and inharmonic factors in complementary colors

You know that complementary colors are the ones that create the greatest contrast between one another within the spectrum range. They are colors that are in maximum opposition, the ones that present the greatest color difference.

You also know that color contrast is subject not only to the *color* factor but also to the *tone* factor (see figure 48). Here is a review:

> **The contrast between two complementary colors is subject to their *tone* and *color*.**

Let me give an example: green is the complementary of red; therefore, when they are placed side by side, they provide a maximum color contrast. But if you translate those two colors into grays (keeping the original *tone*), you will see that the grays are almost the same (figure 129). You can then say that green and red provide a maximum color contrast, but not a major tone contrast. As a result, this lack of contrast, this similarity in tone, and this maximum color opposition are quite unpleasant to look at and unbalances the optic nerves. It can even cause a kind of vibration that can disturb your normal vision. The classic example of this extremely annoying vibration can be seen in the example with red letters painted on a broad green background (figure 130).

Thus, the following factor is very important for you to remember:

> **Two complementary colors that are *equal in tone* are completely incompatible in harmonization.**

This incompatibility is more accentuated in some complementary colors than in others. For instance, between dark yellow and blue (complementaries), harmony is possible insofar as they provide a contrast not only in color but also in tone; while this harmony is not possible between magenta and green, cyan blue and red, and so on. How then can you take advantage of the wealth of colors of the complementaries? Simply by creating tone and color contrast with them. This means mixing the complementary colors in unequal proportions and lightening them with white. In figure 131, there are several graphic examples of this formula, which allows you to create an exceptional range of shades and colors—a range of broken colors, based on a mixture of complementary colors in unequal proportions.

This leads me directly to the study of a range that is exceptional for its wealth and refinement: a range based on the neutralized mixture of complementary colors.

Fig. 131. By mixing two complementary colors in unequal proportions and adding white, you will obtain "dirty," broken colors, with which you can obtain an exceptional color harmony.

EQUALITY OF TONE

129

ABCDEFGH

130

131

A range of broken colors from a mixture of complementary colors

When you mix two complementary colors, green and red, for example, do you know what happens? You get a very dark, almost black color. Suppose you mix them in unequal parts . . . you will obtain either a dirty red, leaning toward sienna, or a grayish green with a reddish tendency—according to whether there is a predominance of green or red. Finally, imagine that you tone down both colors with white and then mix them together.

By doing so, you will obtain a wide range of grays: some stained with red, others with green, others with sienna, some even with an ochre tint, and so on.

The harmonic range of grays is achieved through mixtures of complementary colors; instead of using only two complementary colors, all the complementary colors are used. The following is the formula:

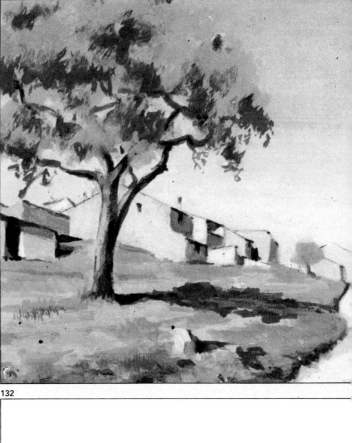

132

> **The harmonic range of grays, through the mixture of complementary colors, is composed of pairs of complementary colors mixed in unequal proportions and grayed with white.**

This combination gives a range of neutralized grays, extremely effective and of high artistic quality. A range in which the true dominant color is gray . . . but with enough color for the picture not to look subdued, monotonous, or dirty. See for yourself, look at the colors on the range palette (figure 135). Notice how the white is decisive in eliminating strident notes, attenuating *color*, but not *tone*, and enhancing contrasts. This is how you obtain an exceptional picture, with subtle harmonization that is delicate in color, yet energetic in *tone* (figures 132 and 134). Finally, remember that the choice of complementary colors and dominant colors depends on the subject.

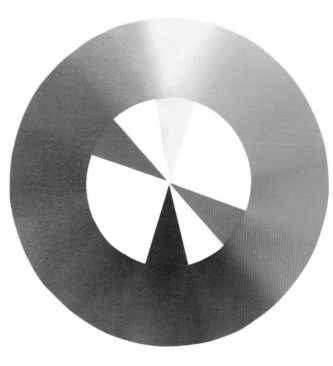

133

Fig. 134. J. M. Parramón, *Lemonade,* private collection. The extreme qualities of the grays, a mixture of complementary colors in unequal parts grayed with white, is evident here with all its expressive possibilities. There is no need for black to obtain these delicate shades; just the combination of the complementary colors with white.

Harmonic range of cool colors

> **The cool color range is basically composed of light green, green, dark green, cyan blue, ultramarine blue, dark blue, and violet.**

136

This type of range is the very essence of color harmonization:

the ranges of thermal colors.

Thermal colors are the same as "colors with temperature," which are,

cool colors and warm colors.

When the light of the atmosphere is your subject, the colors are always, or almost always, influenced by the *temperature of the light of the atmosphere.* A specific example will help you understand what I mean by the "temperature of the light of the atmosphere." Imagine this landscape, with the tree in the middle ground and houses in the background. Try to visualize this scene; it is 9:00 o'clock in the morning on a winter day with a slightly cloudy sky. The sunlight is weak and the chill of the morning has left a mist, which wraps the shapes in a bluish tonality. All the colors are touched by this grayish blue; even the greens appear to be veiled in blue and have a grayish blue, a violet tone (fig. 136).

So what you have is a picture in blue, a typical example of *cool colors*, with blue as the dominant, basic color. But beware! The range of cool colors listed at the top of this page and the spread of colors of the spectrum range (fig. 137) are not, and must not be, ranges that exclude other warm colors, such as yellow, sienna, or red. In these cases, as in all color harmonizations, the *range* must represent a tendency of a color, or of a range of colors.

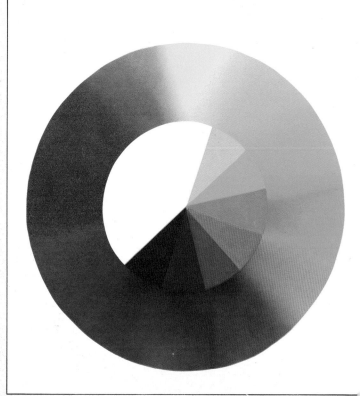

137

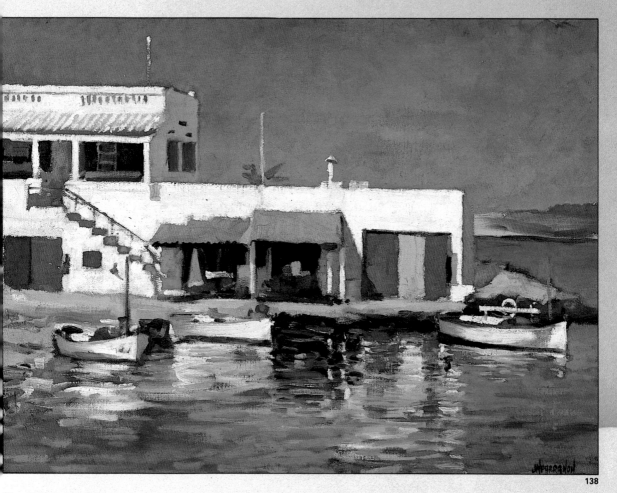

138

Fig. 138. J. M. Parra-
món, *Fornells*, private
collection. This painting
is a typical example of a
cool color range.

Harmonic range of warm colors

> **The warm color range is composed essentially of violet, magenta, crimson, red, orange, yellow, and light green.**

When you compare these colors with the colors in the cool range, you will notice that the light green and the violet are part of both ranges. They are neutral colors that can be either warm or cool, depending on the influence of the other colors in the picture.

Now imagine the scenes on the opposite page. It is a clear day and there is strong sunlight; it is late evening, when the sun is almost red and its rays bathe the landscape with an intense light. All the colors are influenced by the sun's rays. The walls of the nearest houses appear to be orange, golden ochre, and a mixture of sienna and yellow. Both paintings are dominated by the influence of yellow and red (figures 141 and 142).

These are clearly warm, dominant colors, typical examples of *warm colors.*

You must also remember that the harmonic range of warm colors does not exclude green, blue, and violet, which may be present in the picture, but they are always in lesser proportions, with a warm tendency.

However, knowledge and mastery of the *harmonic ranges of thermal colors* can also help you obtain a greater effect of depth.

It has been proven that warm colors, especially yellow and red, create an illusion of proximity, while cool colors, especially blue and violet, create a sensation of distance.

Let us recall these psycho-physical effects and emphasize that:

> **Yellow and red promote a sensation of proximity. Blue and violet promote a sensation of distance.**

It is helpful to remember these qualities when you are composing a still life. For example, you can establish a dramatic ordering of the different grounds with these colors, thus increasing the sensation of depth.

Fig. 141. J. M. Parramón, *The Street,* private collection. A picture harmonized with a warm color range. The colors were provided by the subject, a street on a summer afternoon, when the sun painted the houses yellow, ochre, sienna . . . not excluding some blues with a warm tendency.

140

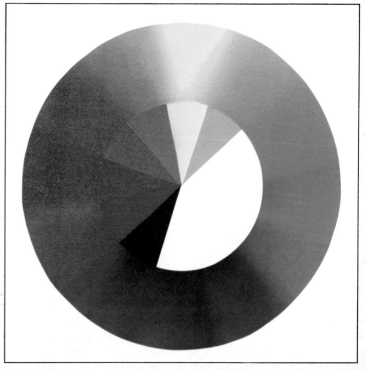

141

142

143

Consonance and dissonance

It has been said that consonance is the equivalent of static, classical beauty; while dissonance is more closely associated with dynamic or modern beauty. Without entering into any philosophical intricacies, I think you can understand that your mind is usually biased toward order without complications, toward beauty in its most primary or rational sense. For example, in general, a child prefers the square to the rectangle, the circle to the oval. He finds that the primary shapes—the square and the circle—are perfect, and sees the rectangle and the oval as less symmetrical, less calculated.

But as time goes by, this child—now a man—broadens his knowledge; he studies, evolves, demands more, and wants more. When he reaches a higher level, he sees that the rectangle and the oval—this is just an example—are equally beautiful because they are asymmetrical. In the end, he understands that beauty is almost always linked with imagination, with exception. As a result, he understands that *art cannot be subject to fixed rules.*

Harmonic music is based on the consonance of sound. This consonance is founded on the association of notes separated by particular intervals. For many years, no one dared to compose music with dissonance. When a dissonance appeared, it was said (and it is still said, unless the dissonance is calculated) that the singer, or the musician, had made a mistake, or was out of tune. But with time, classical musicians, from Johann Sebastian Bach to Richard Wagner and Richard Strauss, found an excess of perfection in the music performed in their respective eras; they saw it as "too square" . . .

144

and decided to transgress its symmetrical rules. They thought of the calculated beauty of the rectangle and launched out to include dissonances, sounds which were apparently out of tune, in their great scores. Of course, they had to struggle for the audience to accept their revolutionary, dynamic way of composing music, but then, as time went by, it was admitted that these dissonances gave even greater brilliance to the consonances. They enhanced them and emphasized the overall harmonic value.

Well then, to return to painting—the melodic, harmonic, or thermal ranges, warm or cool—all the ranges are like one of those perfect consonances in music, with very subtle notes or colors of an opposing tendency, with no bold blues interfering in the warm ranges and no blazing reds in the cool ranges. But, as in music, this kind of harmonization represents a perfection that is too studied and lacks in originality. And so, in painting, too, it is important to use dissonances of color and contrast. The following is the "war cry" of modern art, pronounced by Maurice Denis (the leader of "the Nabis," who defended areas of flat, bold colors):

Remember that before a picture is a horse, a nude, or an anecdotal thing, it is essentially a flat surface covered with color according to a certain order.

145

147

146

148

Fig. 144. Henri Matisse (1869-1954), *The Red Room,* Hermitage, Leningrad.

Figs. 145 to 148. Henri Matisse (1869-1954), *The Dance,* Hermitage, Leningrad; Vincent van Gogh (1853-1890), *Women in Arles,* Hermitage, Leningrad; Paul Gauguin (1848-1903), *Tahitian Pastorals,* Hermitage, Leningrad; Maurice Denis (1870-1943), *Self-Portrait* (detail), Uffizzi Gallery, Florence.

Practical use

In general, and with a practical view of these lessons, you must keep the following in mind when using color harmonization in a painting:

1. **Study the chromatic tendency provided by nature itself in the subject.**

I have already said that a chromatic tendency always exists. There is always *a luminous tendency in any subject that relates some colors with others as well as among themselves.* Nevertheless, sometimes during certain times of the day, or in certain conditions of light, the chromatic tendency is less evident and may pass unnoticed by the amateur painter. You have to make an effort to see it . . . or to imagine it. In any case, you have to try to relate the subject and the expressive possibilities of the subject with a given color, because, often, it is the artist himself who creates this luminous tendency. In painting interiors, still lifes, portraits, figure compositions, and so on, it is almost always possible to create the chromatic tendency from the color of the subject itself, through the (reflected) light of the atmosphere and the color of light itself.

2. **Choose the most appropriate harmonizing range, according to this tendency.**

If the subject provides a very defined chromatic tendency, a very similar coloring, think about putting the harmonic range formula into use. Start the picture by subjecting yourself to the few colors of that range . . . perhaps thinking of widening the number of colors later—creating new shades, always within the range of the dominant color. If the subject does not have well-defined colors, but does have different shades where everything in it seems to tend to gray, you should remember the possibilities of the harmonic range of grays through the mixture of complementary colors. You should try to mix and create these grays, enliven them with the predominance of one color over another. Finally, whatever color you choose, always consider the possibility of adapting it to a range of cool or warm colors, bearing in mind that this is the decisive factor in obtaining a well-harmonized coloring. Remember that it is also useful to "create variety within unity" (the color unity is initially obtained by the primacy of a dominant color). Then, add a contrast of opposing shades, even the premeditated dissonance of colors that belong to the opposite range.

3. **Accentuate this tendency and dramatize it to obtain a greater artistic and expressive quality.**

The creative artist does not settle for discovering and applying one particular range of colors. His ideal often consists of "giving in" to this range, of accentuating it by dramatizing the color and the dominant tendency. As a result, he is able to express himself with greater force and originality.

* * *

Imagine yourself in front of a white canvas looking at the subject, with the palette and the brushes ready.
This is the moment to use your imagination and make decisions about *your picture*. Should you paint by bringing out the color range provided by the subject, by inventing the range of broken colors, by inventing a warm dominant, or perhaps . . .
The decision is yours. It's up to you.

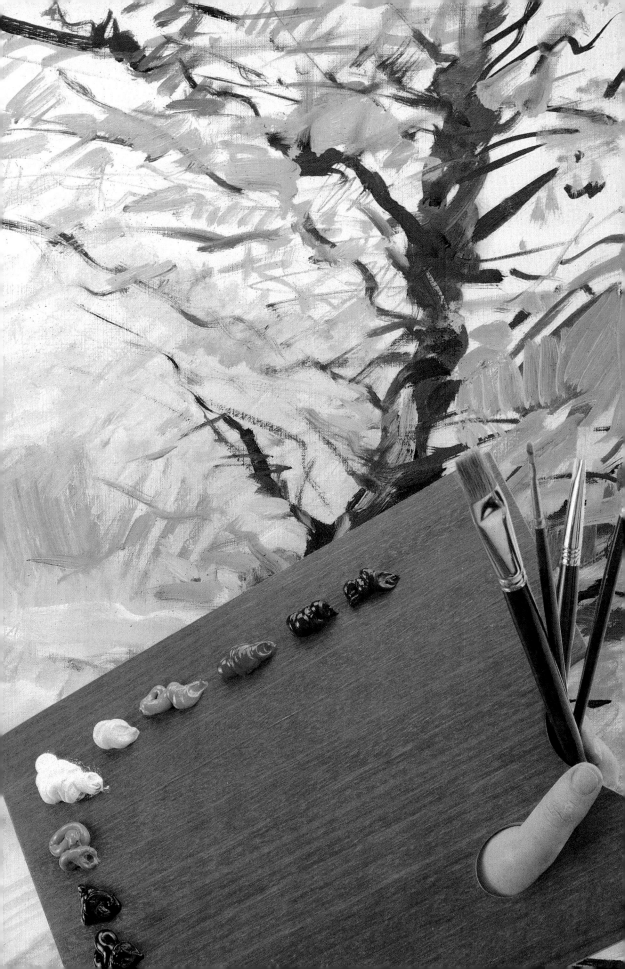

A summary of the lessons

1. Light is composed of the colors of the spectrum. Therefore, light "paints" objects, which reflect all or part of the colors of the spectrum. The basic colors used by the painter are the colors of the spectrum. This is why you can reproduce all the colors of nature with considerable fidelity.

2. Once you start to paint, you have to distinguish, among the colors of objects: a) the local color or color of the body itself; b) the tonal color, or the local color changed by the effects of light and shadow; c) the atmospheric color, or colors reflected by other nearby objects. These three factors in the color of objects are, in turn, conditioned by: the color of the light itself, the intensity of the light, and the intervening atmosphere.

3. By using the three primary colors —cyan blue, magenta, and yellow—you can create all the colors in nature, including black.

4. When you talk about contrast, you must distinguish between color contrast by tone and color contrast by color. A light blue and a dark blue create a tonal contrast. A blue and red create a color contrast.

5. The mixture of two complementary colors creates black.

6. Maximum color contrast comes from the juxtaposition of two complementary colors.

7. A color throws its own complementary onto the neighboring color. For example, a yellow color induces a blue tinge (the complementary of yellow) in the colors that border on it, or are superimposed on it. This rule means that in order to modify a particular color to a certain extent, it may be sufficient to just change the background color.

8. The color gray is composed of 50% black and 50% white. Therefore, if you simply add white to a particular color, you lighten it by making it grayer. The same can be said of darkening a color simply by adding black. To lighten or darken a color, you have to bear in mind the previous and subsequent shades of that same color within the spectrum.

9. The color of shadows is composed of the following mixtures: a) the color blue, which is present in all darkness; b) the local color in a darker tone; and c) the complementary of the local color in each object.

0. By harmonizing colors, you are finding the concordance of one color in relation to another, or of various colors among themselves. This establishes a whole that is pleasing to the spirit. The concordance of colors is based on the knowledge and use of different ranges of colors. Range is any perfectly ordered succession of colors or tones.

11. Two complementary colors that are equal in tone, for instance, magenta and green, are totally incompatible in harmonization. But harmonization can be achieved by mixing two complementary colors in unequal proportions with white.

12. In the color harmonization by ranges, there is always a dominant color. This dominant color may be cool or warm. The most characteristic of the cool colors is blue; the most characteristic of the warm colors is red.

13. In a harmonization of perfectly consonant colors—that is, of the same range, cool or warm—it is desirable to have one or two dissonant notes, which help to bring out the dominant range by contrast.